DEANS' CHOICE
CATHEDRAL TREASURES OF ENGLAND AND WALES

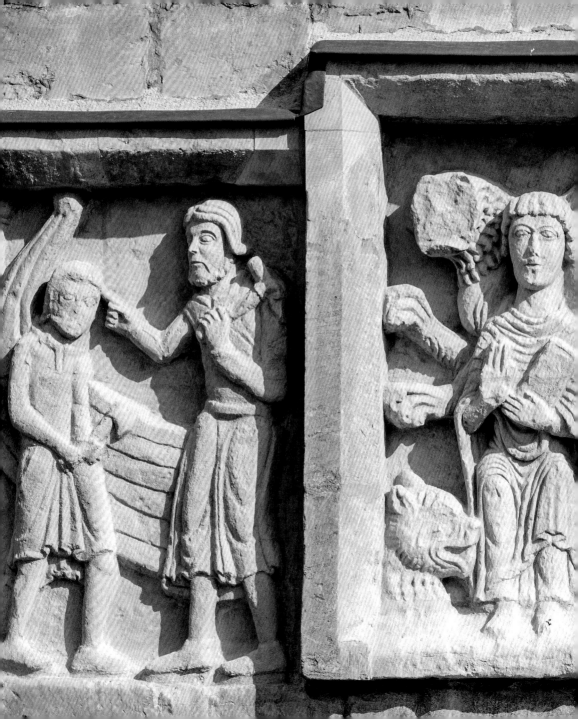

CATHEDRAL TREASURES OF ENGLAND AND WALES

Janet Gough

SCALA

FOREWORD

On entering any cathedral, my immediate reaction is awe. Soaring naves, shafts of light through windows, the majesty of ancient stone buttresses and decorated roofs – there is plenty to inspire.

But look a little closer and there is more. Treasures abound, whether in the form of medieval saints' shrines, unique and often illuminated manuscripts, sacred relics or those magnificent windows themselves. And whether the cathedral is ancient or recently established, it is often the treasures that speak most vividly of the place, its history and distinctiveness.

Within these pages Janet Gough takes us on a joyful journey of discovery. The dean of each cathedral in the Church of England and the Church in Wales has volunteered a treasure: perhaps the thing they most value; the quirkiest or most unusual; or something that has lain hidden, out of sight for centuries. While some of the treasures here described will be familiar to you, I can guarantee a few surprises – as well as an urge to see them all.

Travel well, with this beautiful book as your guide. With its help, we see another aspect of our glorious cathedrals and celebrate the diversity of their extraordinary stories.

Dame Fiona Reynolds
Chair, Cathedrals Fabric Commission for England and
former Director of the National Trust

FRONTISPIECE:
Three panels from the newly-conserved Romanesque frieze on the West Front of Lincoln Cathedral, c.1120-60 – Noah and sons building the ark, Daniel in the lions' den and the dove returning to the ark p.57

LEFT Morris & Co. altar frontal, Bradford Cathedral p.73

WORD FROM OUR SPONSOR

I AM DELIGHTED THAT THE Ruddock Foundation for the Arts has helped to produce this important volume, showcasing one treasure from each cathedral in the Church of England and the Church in Wales. When I was chair of the Victoria and Albert Museum I met with Janet and the chair of the Church Buildings Council and expressed the need for museums to work alongside cathedrals and church buildings to share their expertise in support of the conservation and continued enjoyment by the public of the nation's incredible treasures.

The V&A was able to assist the Church with conservation training, curatorial expertise and fundraising, and I am pleased to learn that Dr Pedro Gaspar, the former head of conservation at Churchcare, is now head of conservation at the V&A.

More recently, I served as the chair of the committee that distributed £40 million in government funds over four years under the First World War Centenary Cathedral Repairs Fund. In that capacity I discovered the ongoing financial need not only for sustaining the fabric of these important buildings, but also for preserving the wonderful treasures that they contain.

While the benefits of the National Heritage Lottery Fund grants have been magnificent, they cannot go far enough on their own. It is my firm belief that cathedrals and church buildings across the UK – repositories of our built heritage and material culture that currently receive no regular government funding – should receive annual managed state funding for their repair and conservation.

In the meantime, I commend this initiative and look forward to visiting many more of our cathedrals and their exceptional treasures.

Sir Paul Ruddock
Chairman, the Ruddock Foundation for the Arts and former Chair of the Victoria and Albert Museum

THE RUDDOCK FOUNDATION
FOR THE ARTS

INTRODUCTION

THE CATHEDRALS OF THE CHURCH OF ENGLAND and the Church in Wales are remarkable institutions. They have each remained in continuous use since their establishment as places of Christian worship, one dating from 500 AD, and as centres of service to the community – witness the cathedrals in England and Wales that opened their doors as mass testing and vaccination centres during the height of the Covid-19 pandemic. Cathedrals also commission dazzling works of art, design and architecture, as well as being crucial repositories of our rich national and local histories.

We asked each of the deans, the clerical heads of cathedrals, to select a treasure – a historic or contemporary object deemed of special interest and displayed by each cathedral.

A cathedral is the seat of a bishop and the mother church of a diocese. There are 42 mainland cathedrals in the Church of England, plus Westminster Abbey (place of crowning and royal burial, which was made a cathedral by Henry VIII (r.1509–1547) but later became a royal peculiar) and the cathedral of the Isle of Man. The Church in Wales, several of whose cathedral foundations pre-date St Augustine's arrival in Canterbury in 597, has six cathedrals. For ease of visiting, in this volume we have arranged the cathedrals regionally.

In the Middle Ages at least half of the cathedrals in England and Wales, unlike those in the rest of Europe, were monasteries. Our treasures consequently include monastic cloisters, prior's doors and misericords, while saints' shrines and the medieval pilgrim's boots at Worcester Cathedral attest to the pre-Reformation importance of pilgrimage – a tradition now undergoing a significant revival.

Even before the Reformation, the Crown and Church were closely linked, from royal Anglo-Saxon patronage to the powerful prince bishops of Durham. The Church often found the Crown overbearing, as in the infamous case of the murder by the king's men of Archbishop Thomas Becket (in office 1162–70) in Canterbury Cathedral. In this volume the Dean of Salisbury tells the story of the building of the new Salisbury Cathedral, independent of control by the king and contemporaneous with the sealing of Magna Carta in 1215. Early versions of Magna Carta are owned by

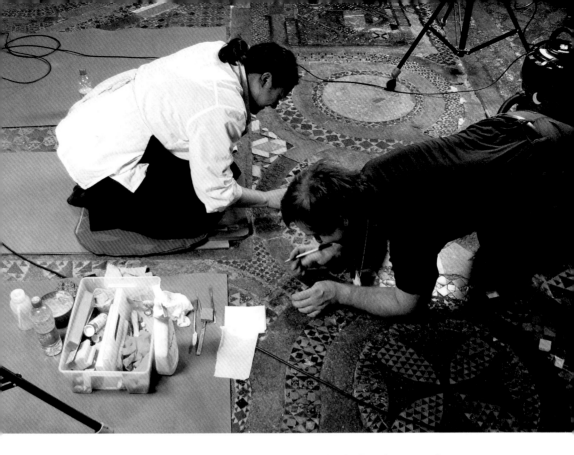

ABOVE Conservators working on the Cosmati pavement, Westminster Abbey p.23

Salisbury and four other English cathedrals – the great charter was as much about protecting the rights of the Church as of the barons.

The Translators' Memorial at St Asaph Cathedral, which is also home to the earliest Elizabethan Bible in Welsh, attests to a huge effort to capture and codify the Welsh language, while in the ancient foundation of Newport the dean has selected as the cathedral's treasure the *Newport Rood* – a newly commissioned artwork by the Singaporean artist Tay Swee Siong (b.1986).

Cathedrals have always showcased magnificent collections – on a family visit to Lichfield Cathedral in 2014 I remember being astounded to see up close the eighth-century St Chad's Gospel, the sculpted Lichfield Angel (*c.*800) and, at that time, religious items from the Anglo-Saxon

Staffordshire Hoard in Lichfield's Chapter House. Treasures were traditionally housed in cathedral treasuries. Today several cathedrals have state-of-the-art displays; recent openings include Durham Cathedral Museum, sited in what was once the monks' dormitory and kitchen, Winchester's Kings and Scribes display in the south transept of the cathedral and Westminster Abbey's Queen's Diamond Jubilee Galleries in the triforium.

Cathedral collections are becoming available digitally. Every page of the early twelfth-century Winchester Bible was digitised during its recent conservation and rebinding. St Albans Cathedral secured Heritage Lottery funding for an innovative project that uses iPads and light projections to display what are thought to be the original colours onto the cathedral's medieval nave wall paintings.

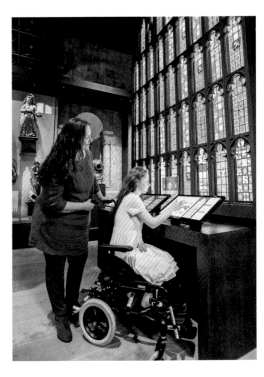

Cathedrals are also generous lenders: Hereford's 1217 Magna Carta has been lent abroad on several occasions, and the Durham Sanctuary ring, the *Textus Roffensis* at Rochester Cathedral, the Lichfield Angel, Canterbury's pocket sundial and the Exeter Book were all displayed at the *Anglo-Saxon Kingdoms: Art, Word, War* exhibition at the British Library.

Three of our cathedrals form part of UNESCO World Heritage sites and several cathedral treasures feature on the UNESCO Memory of the World UK register, including, during the writing of this volume in 2022, the early English laws in *Textus Roffensis*.

Cathedrals are working alongside museums to tell the stories of the development of our nations. Derby Cathedral – beside the earliest industrial silk mill – is building its narratives alongside the Museum of Making. Chelmsford reminds us that cathedrals are in the vanguard of addressing climate and biodiversity crises. Cathedrals are also getting

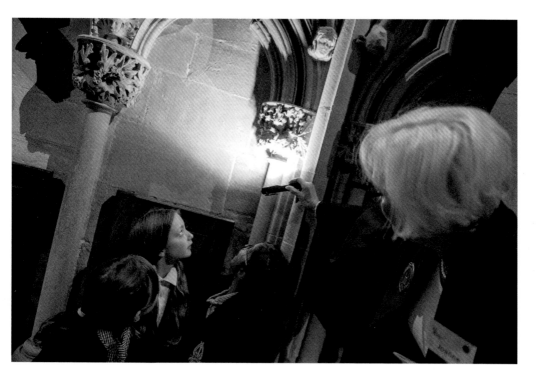

better at recognising the historic contribution of women, but must deal at the same time with difficult histories and contested heritage.

This book is a testament to the work of generations of skilled craftspeople who have created and maintained the stonework, the wood carvings and the embroideries – including the kneelers stitched, mostly by women, at Guildford Cathedral – that are so much a part of what we see in cathedrals today.

The volume furthermore features roods, crosses and liturgical items, since cathedrals are primarily places of worship. The Dean of Hereford reminds us that 'all cathedrals have in common the message of the Gospel, the power of the Holy Spirit and an amazing historical pageant of Godly people who have been the motivation behind so many of the tangible treasures'.

Time for reflection
CANTERBURY CATHEDRAL

Portable sundial (10th century)

Silver with gold cap, chain and pin, L. 6.1 cm, W. 1.6 cm
www.canterbury-cathedral.org 🐦@CburyCathedral

CANTERBURY CATHEDRAL'S POCKET-SIZED SUNDIAL, measuring just over 6 cm in length, was found during excavations in the Great Cloister in 1938. It is made up of a tablet of silver with a cap and chain of gold, and a separate gold pin. The cap is decorated with interlacing; its end is formed as the head of a beast and the chain and pin also are finished with beasts' heads. Two of the heads still have tiny gems for eyes. Abbreviated names of the months in Latin are inscribed in pairs in three lines on both broad faces of the tablet. Around the sides are inscribed words in Latin that translate as 'Health to the maker, peace to the owner'.

The sundial was probably made in the tenth century and it is an intricate piece of design. The pin, known as a 'gnomon', was placed in the hole for the relevant month. When the sundial was suspended from the chain, it used the altitude of the sun to calculate three separate times of the day. The calculations were approximate; they may have been used to indicate times for prayer as part of the divine office.

This sundial is a unique survival from the Anglo-Saxon world. Its maker and original owner are unknown, but it has a traditional, albeit unsubstantiated, association with St Dunstan (d.988), the Archbishop of Canterbury whose reforms led to the establishment of a community of Benedictine monks at the cathedral. A scholar and statesman, he is also thought to have been a skilled musician, scribe and metalworker. He is the patron saint of goldsmiths and silversmiths.

RIGHT Older than any part of the present building, the sundial represents the continuous cycle of worship at the cathedral since its foundation.

BELOW View of Canterbury Cathedral, founded in 597 by St Augustine, and rebuilt in Norman times. It is the seat of the Archbishop and the site of the murder of St Thomas Becket in 1170.

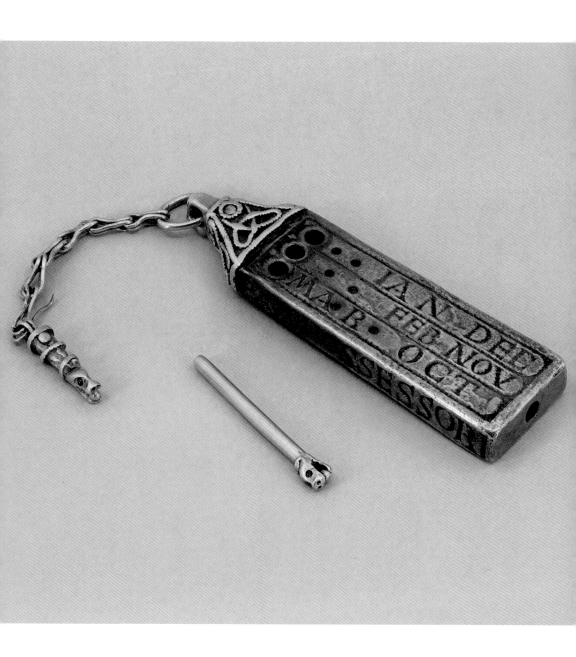

The mid-20th century celebrated in wool and canvas

GUILDFORD CATHEDRAL

Kneelers (begun 1936, completed 1950s–1960s)

Crewel work on linen canvas, filled with horsehair, H. 28 cm, W. 42 cm, D. 5 cm

www.guildford-cathedral.org 🐦@GuildCath

GUILDFORD CATHEDRAL HAS 1,601 KNEELERS; all individually made and each with a story to tell. This huge project was instigated by Lady Maufe (1882–1976) – the wife of the cathedral architect Sir Edward Maufe (1882–1974) – in 1936, the year that saw the cathedral's foundation stone laid. Lady Maufe formed the Guildford Cathedral Broderers' Guild, whose task it was to make the kneelers under her watchful eye. She ensured that the work lived up to the high standards of artistic harmony laid down by Sir Edward.

The Second World War intervened, but work continued after the war, with overseas Friends of Guildford Cathedral offering their work from Australia, New Zealand, Canada and the United States.

The kneelers are divided diagonally; the lower half is blue, to symbolise Stag Hill on which the cathedral is built, and the upper half suggests the sky above.

The range of designs is almost incalculable, but their themes encompass professions, trades, pilgrims, bellringers, gardens and even events such as the 1960 Olympic Games. There are religious symbols such as the descending dove or Pentecost flame, as well as ground plans of the building.

One rather special kneeler recalls the visit of Princess Margaret in 1955. The kneeler depicts a gold cross with a head shaped like a daffodil. Around 15,000 people brought purses of money during the royal visit to contribute to the building of the nave, and the procession was headed by a huge cross made up of daffodils arranged by Mary Lyons. The cross was carried from the pro-cathedral to the unfinished new cathedral.

LEFT Kneelers hang from chairs in the nave, part of the unified mid-20th century masterpiece by Sir Edward with Lady Maufe at Guildford Cathedral.

BELOW Kneeler in homage to Sputnik 1, the first manmade earth satellite, launched by the Soviet Union in October 1957.

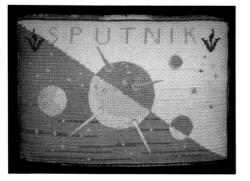

Five hundred years of history in one small volume

ROCHESTER CATHEDRAL

Textus Roffensis (*c*.1123)

Vellum, modern binding; text block H. 23 cm, W. 17 cm

www.rochestercathedral.org 🐦 @RochesterCathed

THE MANUSCRIPT KNOWN TODAY AS *Textus Roffensis* ('the Rochester book'), compiled during the time of Bishop Ernulf of Rochester (in office 1114–24), is without question one of the most important medieval British manuscripts. The first part of the manuscript, often described as a 'legal encyclopaedia', contains copies of many of the early medieval (pre-Conquest) laws that have come down to us, including those of Alfred the Great (848–899), Æthelstan (*c*.894–939), and Æthelred 'the Unready' (968–1016). Uniquely among collections of early English laws, *Textus Roffensis* contains copies of the seventh-century laws of the kingdom of Kent, which represent the nascence of English written law. The earliest of these, the law code of King Æthelberht (589–616), is the earliest datable text composed in English, and thus signifies the birth of English as a language of the page. The law codes open a window onto the lives of women, men and children – free and enslaved, rich and poor – during the first centuries of English history.

The second part of *Textus Roffensis* is the most precious of the cathedral cartularies, a collection of over a hundred charters from as early as the eighth century which extends into the Norman period and up to the establishment of the priory. The two sections were bound together at some point, possibly after 1300.

In 2022 the early English laws in *Textus Roffensis* were added to the UNESCO Memory of the World UK register. The manuscript has featured in major exhibitions at the British Library and alongside the Faversham Magna Carta. The translation of the 170 texts in *Textus Roffensis* into modern English is a major ongoing project, and transcriptions, translations and a high-quality facsimile can all be viewed online.

RIGHT When not exhibited elsewhere, *Textus Roffensis* is housed in a bespoke exhibition area in the crypt of Rochester Cathedral.

BELOW The Queen's Platinum Jubilee service beneath Luke Jerram's earth installation, *Gaia*. Rochester Cathedral hosts exhibitions and events throughout the year.

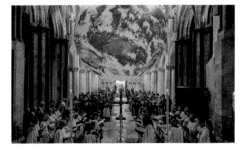

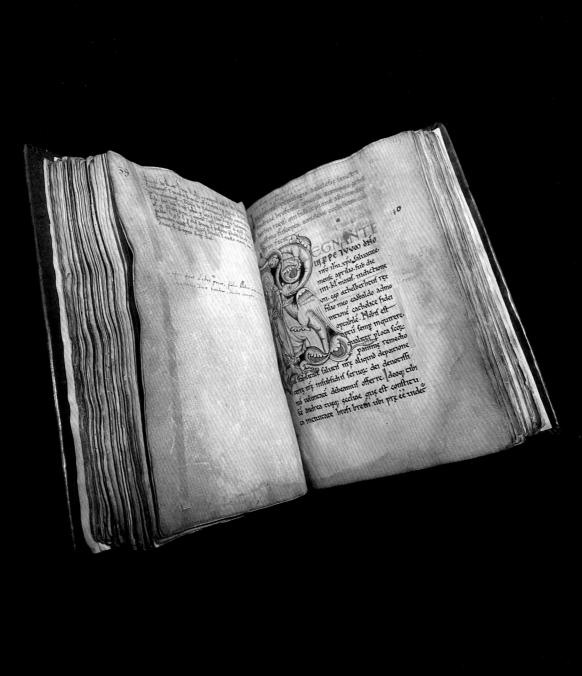

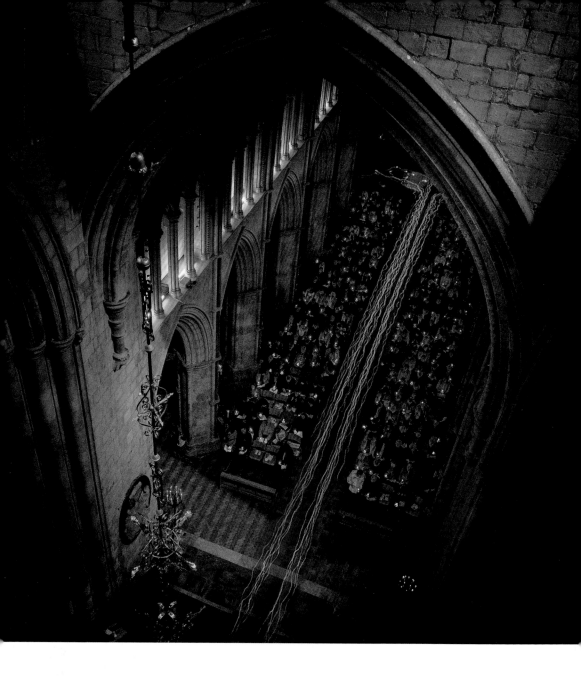

Witness to the Great Fire of Southwark

SOUTHWARK CATHEDRAL, LONDON

Prior's doorway and stoup basin (early 11th century)

Stone; door W. 1.6 m, H. 2.22 m; door and vestibule W. 3.7 m

www.cathedral.southwark.anglican.org 🐦@Southwarkcathed

BUILDINGS OFTEN HAVE COMPLICATED STORIES to tell. Southwark Cathedral may appear to be predominantly Victorian, but closer examination reveals something quite different. The first Augustinian priory of St Mary Overie was built in 1106. That building was essentially destroyed in 1212 during the Great Fire of Southwark, but not everything was lost. The Prior's doorway is part of what remains.

While the canons entered the priory church from the West End, the prior had a much grander entrance. What remains of it are the decorated pillars which formed the sides of the Prior's doorway, some 'zigzag' decoration and, to the left-hand side, a large holy water stoup made from a piece of Tournai marble – a blue, black limestone from Belgium.

The stoup basin is the only known example of a Tournai stoup in England. It may have been made from a damaged font and it may have been a gift from the then-Bishop of Winchester. If the Southwark stoup is indeed the product of such symbolic reuse, then it may have served not just as a vessel for holy water, but also as a memorial of the fire, of what was lost and of episcopal patronage.

The whole doorway in fact tells a tale of destruction and reuse. The intensity of the fire caused the colour of the stone to change, and a pink hue is now visible. As we look at these remains, we recall not only those who came through the doorway and remembered their own baptisms as they dipped their hand in the water of the stoup, but also the process of destruction and restoration to which the doorway bears witness.

Medieval saints restored with light

ST ALBANS CATHEDRAL

Nave wall paintings (early 15th–16th century)

Each painting approx. 3 x 1.2 m

www.stalbanscathedral.org 🐦@StAlbansCath

IN ADDITION TO TWO SURVIVING medieval shrines, St Albans Cathedral has some of the finest medieval wall paintings in England. No other cathedral has preserved so many, ranging from the Romanesque to the Tudor period.

It had long been the wish at the cathedral to see how the paintings might have looked to a medieval pilgrim arriving at the Abbey Church to venerate St Alban. At last, thanks to innovative software and the talent of the historical illustrator Craig Williams, four images have again come alive on the mighty piers of the nave. Painted on a monumental scale (approximately 3 metres high in each case), they represent saints significant both to the foundation of St Albans Abbey and to popular devotion in the Middle Ages. The wall paintings were whitewashed over in 1547, shortly after Edward VI (r.1547–1553) came to the throne, and were not uncovered until after 1846, when scraping began to reveal St Christopher, St Thomas Becket, a figure we believe to be St Sitha and St Alban with the priest he sheltered, St Amphibalus.

Through the deployment of light from four projectors mounted high in the triforium, each image is built up using a 'layering' technique. This strengthens faded lines, replaces missing areas, adds faces and hands and finally shows a full-colour image that is an educated 'artist's impression'. Only the underpainting remains, but by using historical research and comparisons with contemporaneous paintings, Williams has brought these spectacular St Albans images back to life for the modern-day pilgrim.

RIGHT St Sitha of Lucca, identified by her purse, keys and rosary, now brought back to life and full colour using digitally generated light projections.

BELOW St Albans Cathedral's Romanesque nave piers decorated with medieval wall paintings.

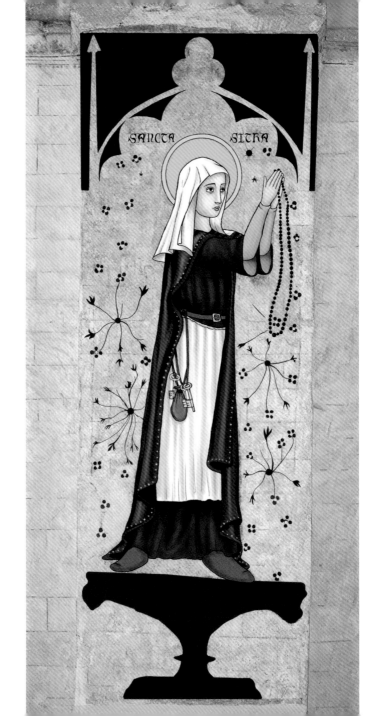

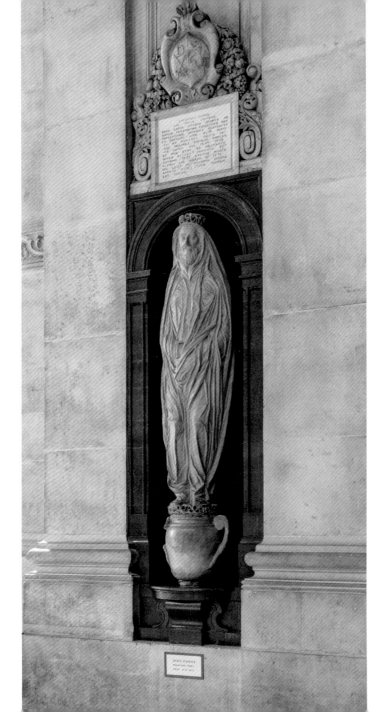

LEFT From old St Paul's – the
funerary memorial to John
Donne (1572–1631), preeminent
metaphysical poet and dean.

RIGHT Restrained arches
and decoration articulate
Sir Christopher Wren's nave
in the UK's first classically
designed cathedral.

Dean, metaphysical poet, soldier, MP and scholar remembered

ST PAUL'S CATHEDRAL, LONDON

Memorial to John Donne (early 17th century, completed 1632)
NICHOLAS STONE (1586–1647)

Stone carving, faint traces of scorching on the statue and urn; H. 2.44 m, W. 5 m; alcove 3.06 x 1.02 m
www.stpauls.co.uk 🐦 @StPaulsLondon

THE MOST FAMOUS DEAN OF ST PAUL'S was dying in his sixtieth year. John Donne was born a Catholic and had been a racy young poet in London who failed to get steady employment, but after being reluctantly ordained at the age of 42 he became a Protestant apologist and then the most famous preacher of his generation.

In preparation for his death, an artist made a drawing of Donne wrapped in a sheet and standing on an urn so that his friend Nicholas Stone could sculpt his memorial for future generations.

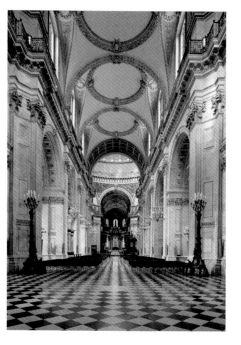

Erected in 1632 and the only statue to survive intact the destruction of St Paul's in the Great Fire of 1666, Donne's stone memorial can now be seen mounted on the wall of the south quire aisle. It shows him rising out of his ashes at the end of time, ready to meet Jesus Christ as his judge. Above the statue is the Latin epitaph he wrote for himself, which says: 'Having been invested with the Deanery of this Church, he was stripped of it by Death on the last day of March 1631: and here, though set in dust, he beholds Him Whose name is the Rising.'

Donne's statue reminds us of a gifted person with a complicated life. He came to trust in God for his own life and death and invites us to do the same. In words recorded by his friend Izaak Walton (1593–1683): 'I cannot plead innocence of life, especially of my youth, but I am to be judged by a merciful God who is not willing to see what I have done amiss... I am therefore full of inexpressible joy and shall die in peace.'

Magnificent import symbolising the power of Rome

WESTMINSTER ABBEY, LONDON

Cosmati pavement (1268)

Porphyry, onyx and glass mosaic set in Purbeck marble, L. 7 m, W. 7 m

www.westminster-abbey.org @wabbey

THE COSMATI PAVEMENT BEFORE THE HIGH ALTAR of Westminster Abbey takes its name from a family of Italian craftsmen who mastered this distinctive style. It was installed in 1268 as part of Henry III's (r.1216–1272) replacement of the Romanesque abbey with a new Gothic church, the eastern portion of which was consecrated the following year. Abbot Richard Ware (d.1283), who had travelled to Rome to receive confirmation of his election as Abbot of Westminster, arranged the transportation to Westminster of porphyry, onyx and glass. These were cut into around 90,000 pieces or 'tesserae' and set in complex geometric designs within a matrix of Purbeck marble.

An inscription, mostly now lost but recorded by earlier writers, suggests that the design symbolises the world and its end. Installing this distinctively Roman style of floor at the heart of the church underlined Westminster Abbey's place in the wider medieval Church – as a monastery exempt from English episcopal authority and instead answerable directly to the Pope.

For most of the twentieth century the pavement lay concealed under carpet. When it was uncovered for three days in 1988 there were long queues to see it. Meticulous conservation has now allowed it to be permanently uncovered and walked on for liturgical purposes.

Another Cosmati pavement, in a different design, surrounds the shrine of St Edward the Confessor (r.1042–1066) to the east of the high altar. The shrine was also originally covered in Cosmati work; so too was Henry III's tomb nearby. Much of that decorative detail has been lost, but enough remains for the original magnificence to be imagined.

RIGHT Henry III spared no expense when he rebuilt Westminster Abbey in the 1260s, as demonstrated by the Cosmati pavement, still at the heart of daily worship.

BELOW The West Towers were finally completed in 1745 to a design by Nicholas Hawksmoor, highly original pupil of Sir Christopher Wren.

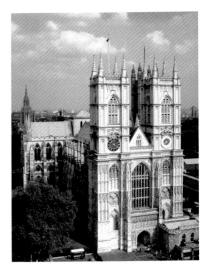

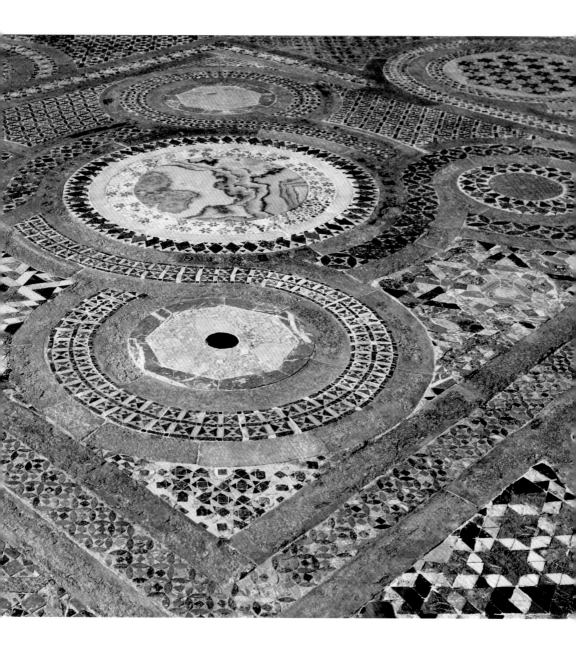

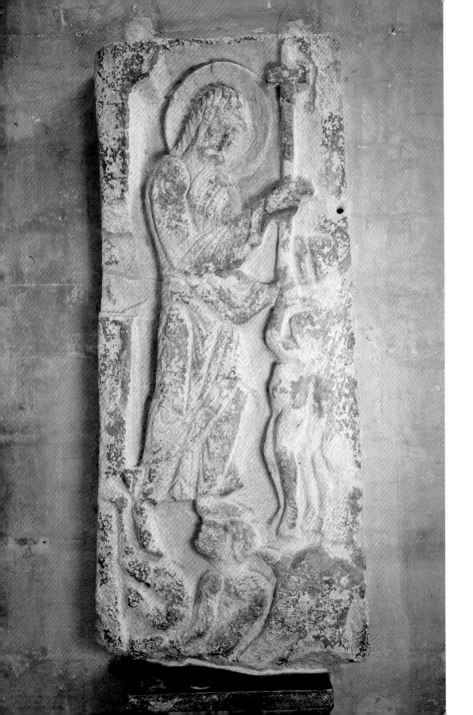

Christ triumphant from Bristol's earliest years

BRISTOL CATHEDRAL

Harrowing of Hell sculpture (*c.*1040)

Jurassic limestone, H. 165 cm, W. 75 cm

www.bristol-cathedral.co.uk @BristolCathedra

THE SOUTH TRANSEPT OF BRISTOL CATHEDRAL is home to a powerful – and very rare – example of Anglo-Saxon sculpture. The story depicted derives from the statement in the Apostles' Creed that Christ descended into hell before his Resurrection. In the carving, Christ meets a host of souls in hell and promises them victory over death. He is depicted as a giant, trampling Satan down into the open, beast-like mouth of hell as a crowd of figures approaches him. The image has all the hierarchical grandeur of early Christian art and embodies the central messages of the Christian faith: redemption and victory over death.

LEFT The *Harrowing of Hell* sculpture, a scriptural sculpture that plays a role in the story of Bristol itself.

The origin of this sculpture is obscure. It is around one hundred years older than the cathedral in which it stands and was discovered in 1831 while being used as a coffin lid. It may have come from a chapel formerly on College Green, just outside the site of the cathedral. In the fourteenth century this chapel is said to have held the relics of St Jordan, an early missionary from Rome. The *Harrowing of Hell* sculpture suggests that a chapel was present before the Norman Conquest.

BELOW Bristol Cathedral, founded as an Augustinian monastery in *c.*1140, was made a cathedral by Henry VIII in the 1540s.

The carving is considered the most significant object to survive from the earliest decades of the city of Bristol. The obscure cult of St Jordan makes it just possible that the sacred enclosure, which is today College Green, is older still.

Resonant poetry and teasing riddles from the 10th century

EXETER CATHEDRAL

Exeter Book (*c*.960–990)

Codex of Old English poetry, originally 130 leaves, H. 33 cm, W. 24 cm

www.exeter-cathedral.org.uk @ExeterCathedral

THE EXETER BOOK IS A UNIQUE, tenth-century collection of poetry in Old English. As the largest, best-preserved and probably earliest of only four surviving Anglo-Saxon books of poetry, it is the oldest book of English literature in the world.

The book's origins remain somewhat mysterious. The poetry was written by a single scribe, most likely a monk, in about 970, but we do not know where or why it was written, or for whom. The elegant script, known as insular miniscule, was common throughout Anglo-Saxon England, but the language suggests a south-west origin, possibly a scriptorium in Crediton or even in Exeter.

The poems vary in length, format, subject and age, some originating in an oral tradition that is centuries older than the book itself. Among the most celebrated are 'The Seafarer' and 'The Wanderer', powerful meditations on loneliness, exile and the passage of time. The Exeter Book also contains nearly all the surviving Old English riddles – just under one hundred – a popular and highly respected form of writing in the tenth century, and, since no answers are given, people are still debating the meaning of some of the riddles today.

Considering its age, the book is in excellent condition. However, signs of wear hint at its changing status over the centuries: a scorch mark, a spill from a glue pot, and other marks suggesting it was once used as a chopping board and press for gold leaf. A thousand years on, the Exeter Book is now entered on the UNESCO Memory of the World UK register in recognition of its enormous literary and cultural significance. It continues to fascinate people of all ages across the world.

RIGHT The Exeter Book of Old English poetry and riddles has remained continuously in Exeter since the first bishop, Leofric, gave it to his cathedral in the 11th century.

BELOW Exeter Cathedral, built in the glorious Decorated Gothic style.

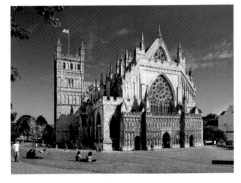

godeſ uſin beorn pihtum inþonlde
leaſ. forþon peſculon ahegende hæld
inmode mæla gehpyrcum þone telefan

ID SIÐ MAÐOL

pord hord onlæc þehe mæſt
ofþan folca gend fſhde ofþe
myrne licne maþþum hine from
le onƿocon hemid ealhhilde
forman ſiþe hreð cyningeſ
of ongle eormanriceſ ƿraþ
þorn myrican fela ic mon
þan rſeal hpoda gehp
van exle pædan

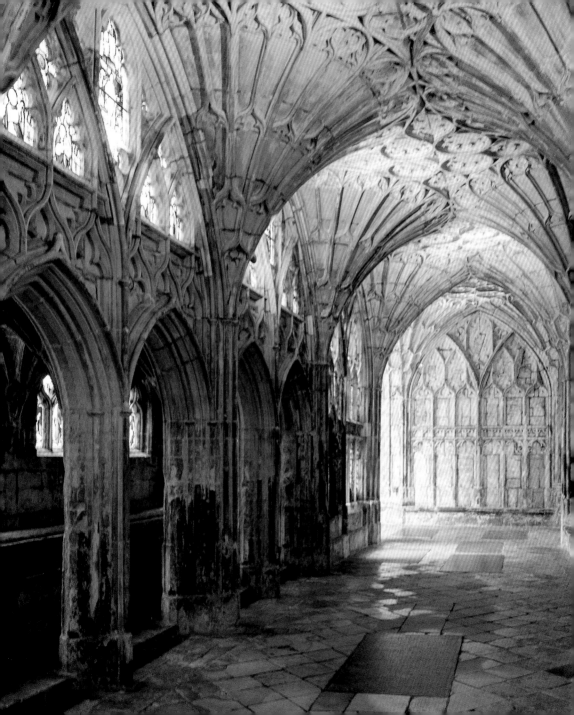

Fan vaulting: a Gloucester invention

GLOUCESTER CATHEDRAL

Cloisters, fan vaulting and monks' games (Norman, later Perpendicular with fan vaulting *c.*1350s–90s)

Painswick stone, 45 m in each direction
www.gloucestercathedral.org.uk 🐦 @GlosCathedral

LEFT View of the lavatorium. Under the fan vaulting the cloisters can feel like a stone forest with branches of the trees on either side reaching across and forming a canopy.

BELOW This fox and geese game board is in the north walk, close to the lavatorium and the refectory. It is on the opposite side from the monastic carrels where monks read and copied their books.

THE CLOISTERS ARE THE GREAT ARCHITECTURAL treasure of Gloucester Cathedral. They formed the heart of the monks' lives at Gloucester from the 1090s until the dissolution in 1540. The monks lived, ate, worshipped and worked around the four sides of this garden space.

The glory of the cloisters is the fan vaulting, which dates from between the 1350s and the 1390s. This is a development of the new style of English Perpendicular Gothic architecture, whereby the panels that already covered the walls and windows were extended up onto the ceiling to meet each other overhead. It is called 'fan vaulting' because it is formed of hollow cones or 'fans', with decorative tracery forming part of each stone. The fans would have been made in a workshop and then assembled piece by piece in situ. This form of ceiling on this scale was invented and first used in Gloucester.

Amidst the beauty of the architecture are some hidden treasures: medieval games. Boards are scratched into the surface of the seating on the far side of the cloisters. They were used for two medieval games: fox and geese and nine men's morris. Modern versions of the game boards are now carved into stones in Upper College Green so that visitors can play.

Although some of the boards have since been obscured by graffiti or repairs, you can still see, on close inspection, the marks left by monks, novices and singing boys enjoying the opportunity to relax.

Vista of Biblical and church history in stained glass

TRURO CATHEDRAL

Master Scheme: designs for 80 windows (first published 1887)
Clayton and Bell glassmakers (active 1855–1993)

Stained glass, Church History windows (north and south of nave), 79 x 439 cm
www.trurocathedral.org.uk 🐦@TruroCathedral

The stained glass of Truro Cathedral is perhaps the building's crowning glory. The 'Master Scheme', as it was called, was conceived as a collaboration between the architect, John Loughborough Pearson (1817–1897), the first Bishop of Truro, Edward White Benson (in office 1882–96), and one of the first canons of the cathedral, Arthur James Mason (1851–1928). It was unique in its ambition, scope and comprehensiveness, being the largest stained-glass project ever executed, and it has some of the finest Victorian stained glass in the country (produced by Clayton and Bell, the leading stained-glass company of the time).

The design – which incorporates three rose windows at the West End, the two transepts and the windows around the building – adopts a theological and historical scheme. It proclaims the nature of the Trinity in the rose windows and it tells the story of the Bible and of English and Cornish Christianity by focusing on its leading figures, culminating in Benson being supported by both Faith and Hope in the final window.

The full scheme was subject to various revisions during the building work, and both Benson and Mason continued to be involved even after they had left Truro, thereby ensuring an integrated approach to the scheme. The windows in the baptistery are devoted to Henry Martyn (1781–1812), the great missionary who came from Truro and translated the scriptures into Urdu and Persian.

RIGHT The lower section of the north nave aisle window, 1903, depicts The Prince of Wales laying the foundation stone of Truro Cathedral 20 May 1880. Behind him stand Princess Alexandra, Pearson (partially hidden), the cathedral architect, and Benson, who later became Archbishop of Canterbury.

BELOW John Loughborough Pearson's Truro Cathedral from the south-west.

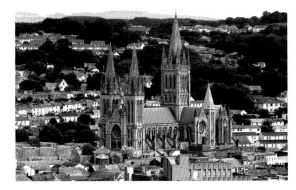

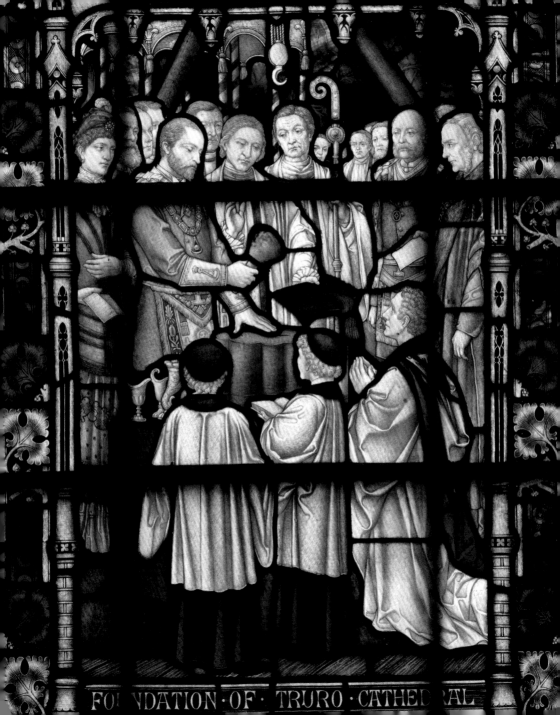

FOUNDATION · OF · TRURO · CATHEDRAL

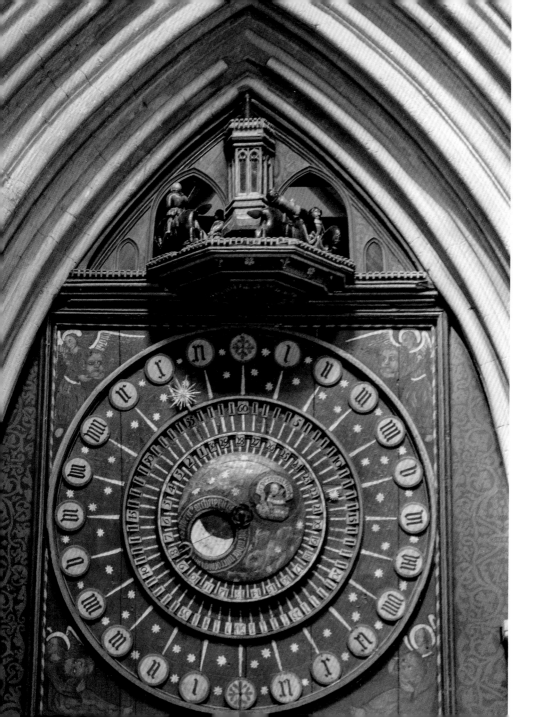

Tempus fugit: time flies at Wells

WELLS CATHEDRAL

Astronomical clock (*c.*1390)

Dial plate: oak boards, painted scales and numerals, 2.07 m²
www.wellscathedral.org.uk 🐦@WellsCathedral1

LEFT Prominent inside and outside the north transept, Wells Cathedral's clock has provided precise timekeeping to regulate the many services since the late 14th century.

BELOW Scissor strainer arches were the cathedral's masons' ingenious and effective solution after cracks appeared around the crossing tower in 1338.

WELLS CATHEDRAL, ITSELF AROUND EIGHT HUNDRED and fifty years old, is the second major church to stand on this site. It is sometimes referred to as the 'new cathedral' to make this point, and the same is true of some of the cathedral's treasures: the 'new' clock, for example, dates from about 1390, having replaced one that pre-dated it by at least a hundred years.

On this astronomical 24-hour dial, midday is at the top and midnight at the bottom. The hour hand is a golden representation of the sun and the whole face is a representation of the medieval universe. The sun moves against a background of fixed stars and Earth is right in the middle of the clock face. Beyond the hour markers, at each of the four corners, an angel holds a face that is blowing towards the Earth. These are the four winds, blowing from the four corners (or compass points) of the world. The minute hand, a small star inside the orbit of the sun, was added in the early eighteenth century. At the centre there is a scale of 30 divisions recording the moon's age, accurate to one day in every 33 months.

Above the clock face, knights have a jousting match every quarter. If you come to see the clock, watch for the one who gets knocked off his horse every time he comes around. He has never got any better at jousting in over six hundred years. Above and to the right of the clock face you can also see Jack Blandiver (120 cm tall): he chimes the quarters with his heels and strikes the bell in front of him for the hours.

The medieval mechanism is still in working order but is now in the Science Museum. The Victorians installed the current mechanism, which operates not only the astronomical dial, but also the late fifteenth-century dial on the outside face of the north transept. This was converted to a 12-hour scale in 1836.

Grief and resurrection in carvings hidden for centuries

CHICHESTER CATHEDRAL

Chichester reliefs (early medieval)

Two panel sculptures: Caen stone, originally painted and with jewels, some fire discolouration. Christ meeting Martha and Mary, 1.35 x 1.35 m. This relief includes a surviving acanthus border at the top of the scene.

The raising of Lazarus 1.2 x 1.3 m.

www.chichestercathedral.org.uk 🐦@ChiCathedral

THERE ARE TWO PANEL SCULPTURES in the south quire aisle of Chichester Cathedral. They illustrate the story of Lazarus. In the first sculpture Lazarus has been dead for four days. His sisters, Mary and Martha, have sent for Jesus in the belief that their brother can be saved. They are shown kneeling and grieving at the town gate of Bethany. In the second sculpture Jesus raises Lazarus, who is still bound in grave clothes. Mary and Martha look on with astonished expressions. Also depicted are some of the disciples and two aggrieved gravediggers.

In line with convention, the most important figure – Jesus – is the tallest. The narrative is conveyed by well cut, sharply defined faces showing intense grief and awe; the overwhelming feeling expressed in the drama is a sense of pathos. Originally the sculptures would have been painted, with jewels in the eye sockets. The discolouration is probably the effect of a fire that took place in 1187.

Nairn and Pevsner (1965) held the view that these panels are 'the most memorable things' in the entire cathedral. They were discovered in 1829, hidden behind the choir stalls, and are thought to be part of a chancel screen.

The date and origin of the panels is uncertain. In Arthur Mee's guidebook of 1937 they are called 'The Saxon Panels from Selsey's Lost Cathedral'. In the 1950s Professor George Zarnecki of the Courtauld Institute made a detailed analysis and concluded they were made in the second quarter of the twelfth century. Recently discovered Saxon carvings show interesting similarities to the Chichester panels.

RIGHT The story of the raising of Lazarus from John chapter 11 in two low-relief stone panels. This first panel has eleven figures.

BELOW Nave looking west at Chichester Cathedral. The slim dark pillars are Purbeck marble and reputedly donated by King John (r.1199–1216).

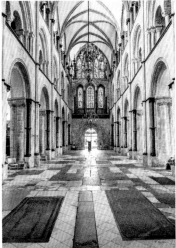

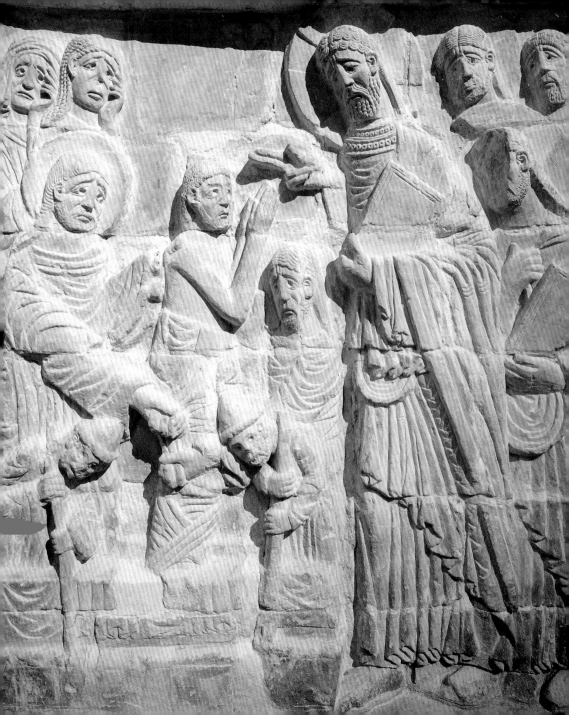

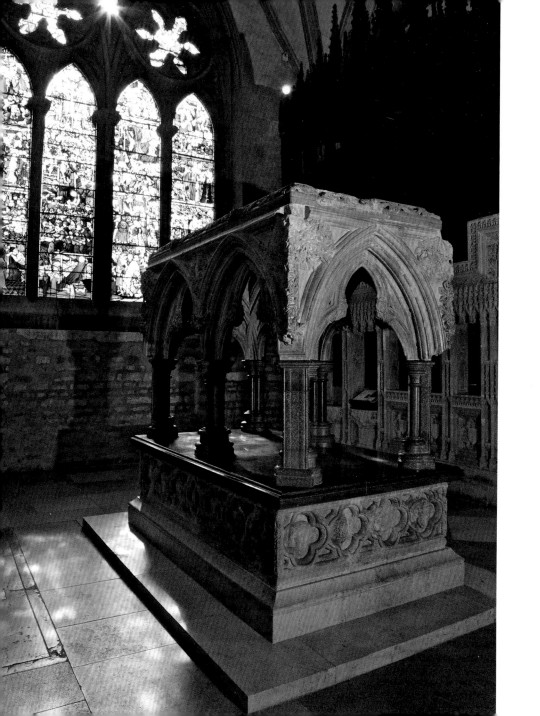

Venerated place of pilgrimage and prayer to a healing saint

CHRIST CHURCH CATHEDRAL, OXFORD

Shrine of St Frideswide (1289)

Purbeck marble, shelly limestone and modern carbon fibre, H. 2 m, W. 1.19 m, L. 2.01 m excluding
the modern plinth

www.chch.ox.ac.uk/cathedral 🐦@ChChCathedralOx

SINCE CATHEDRALS ARE SERMONS IN STONE, the most valuable treasure of Christ Church is 'the stone that was rejected which became the cornerstone' (Psalm 118: 22 and Acts 4: 11). That stone is the Shrine to St Frideswide, which would have housed the reliquary of this early Saxon saint. Frideswide was the abbess of her monastery until her death around AD 727. She was buried in the abbey, and her shrine quickly became associated with healings and cures.

Oxford was almost destroyed by the violence that engulfed the city during the St Brice's Day Massacre of 1002. In 1180 Frideswide's remains were moved into a new shrine in the monastery church (now Christ Church Cathedral), as witnessed by Henry II (r.1135–1154). Frideswide was now Patron Saint of the City and University of Oxford.

LEFT The shrine of St Frideswide, patron saint of Oxford, lies at the heart of the cathedral.

BELOW Christ Church Cathedral, Oxford – uniquely both a cathedral and college chapel – from Christ Church Meadow.

Frideswide's current shrine dates from around 1289 and would once have been gilded with precious metals and jewels. It was subsequently destroyed and stripped of everything valuable – under Reformation-era legislation that abolished 'superstitious memorials' – but the shrine endured these ravages and was partially restored under Mary I in 1588.

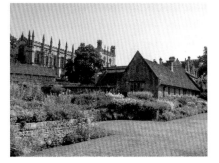

The original sculpting remains largely intact, and the carvings of foliage carry a wealth of spiritual and medicinal associations. The shrine also features several faces, including Frideswide herself (partial, and probably mutilated in 1538), companion nuns of the saint and characters featured in her illuminating Saxon saga.

Frideswide's stripped shrine and Matthew 6: 19–21 remind us, 'do not store up for yourselves treasures on earth … but store up for yourselves treasures in heaven … for where your treasure is, there your heart will be.'

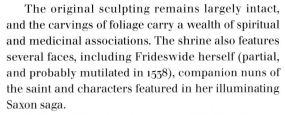

Seafarer's landmark and symbol of the 'Cathedral of the Sea'

PORTSMOUTH CATHEDRAL

Golden Barque weathervane (1710)

Gilded sheet copper, H. 1.86 m, W. 1.36 m

www.portsmouthcathedral.org.uk 🐦@PortsmouthCath

BETWEEN 1710 AND 1954, THE GOLDEN BARQUE weathervane on the tower of Portsmouth Cathedral was a landmark for shipping entering or leaving the nearby harbour. It is now just inside the cathedral's south door, greeting visitors with a reminder that they are entering the 'Cathedral of the Sea'. The maritime identity of Portsmouth carries with it a continual sense of both the power of the sea and human fragility. The cathedral itself has many naval memorials – from the tomb of 'a member of the ship's company of the *Mary Rose*' (which sank in the Solent in 1545) to the HMS *Glamorgan* window (in memory of those killed during the Falklands War of 1982, when the ship was hit by an Exocet missile).

RIGHT The Golden Barque weathervane, displayed in the north ambulatory of the nave since it blew down in 1954.

As for the 1710 Golden Barque, the story behind its commissioning is not a happy one. It involves a financial dispute between two churchwardens and their vicar, William Ward (1674–1724), which culminated in the churchwardens having Ward arrested and jailed on a trumped-up charge. Fourteen months after his release, a bishop's court decided that church fees held onto by the churchwardens were rightfully due to Ward. New wardens were appointed, and they made the shrewd suggestion that some of the money should be spent on the erection of the Golden Barque.

BELOW View of Portsmouth Cathedral and the sea-channel off the Solent into Portsmouth harbour. The wooden cupola with a lantern for shipping was added in 1703.

Today a successor weathervane, very similar in design, crowns the cathedral tower and continues to alert passers-by on land and sea to the ongoing life and work of Portsmouth Cathedral.

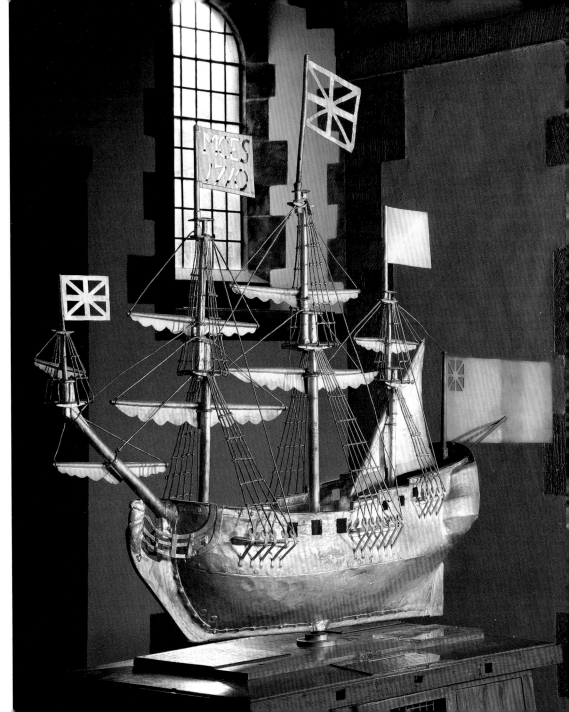

Treasured document of freedom

SALISBURY CATHEDRAL

Magna Carta (1215)

Sheepskin parchment, 44.4–45.6 x 34.8–35.2 cm

www.salisburycathedral.org.uk 🐦@SalisburyCath

SALISBURY IS THE CATHEDRAL THAT moved: in 1220 work began on a new building on a new site only two miles from the hilltop where the Norman cathedral had stood since 1075. Chief among the reasons for the move was the uncomfortable proximity of the bishop's cathedral to the king's castle, which was a significant feature of life at Old Sarum.

The move to New Sarum, where the cathedral and city still stand, was an audacious bid for the liberty of the church. When the cathedral community's belongings were transported to their new home, there was among them a copy of Magna Carta, the ink barely dry on the sheepskin parchment.

LEFT The best preserved of only four surviving Magna Carta documents from 1215, Salisbury Cathedral's copy is displayed in the Chapter House.

One of the great architects of the agreement forged between King John (1199–1216) and the barons at Runnymede in 1215 was Archbishop Stephen Langton. His steward, Elias of Dereham, was at his side during the negotiations and was one of the commissioners responsible for ensuring that copies of the charter were safely delivered around the kingdom. Elias was also a canon of Salisbury. He oversaw the design and construction of the new cathedral – so it is no surprise that one of the copies made its way to Old Sarum and then to New Sarum, where it has remained ever since.

BELOW Salisbury boasts the largest cathedral cloister in the UK, linking church and Chapter House, with 1260s cutting-edge Gothic in its rib vaulting and geometrical tracery.

The principal treasure of a cathedral built as a bid for liberty is a document that, in its potent symbolism of the struggle to rein in unchecked power, has become truly iconic, having inspired movements of resistance and liberation around the world. Magna Carta is also an eloquent expression of the Gospel of Jesus Christ, who in Nazareth announces that he has come 'to proclaim to the captives … to let the oppressed go free' (Luke 4:18).

Lavish medieval Bible produced on site and still in use

WINCHESTER CATHEDRAL

Winchester Bible (1150–1175)

Vellum, folios approx. 58.3 x 39.6 cm
www.winchester-cathedral.org.uk 🐦@WinCathedral

THE TWELFTH-CENTURY WINCHESTER BIBLE is unique in at least two respects. First, it has stayed for the last eight hundred and fifty years or so in the place where it was made – the monastic Priory of St Swithun, now Winchester Cathedral. Bibles in churches may seem commonplace, but a handmade Bible of this quality was rare, and produced at enormous expense by an individual of great wealth and power. The cost lay not in the text but in the 'historiated' (story-telling) illuminated initials at the start of each of the Bible's books, undertaken in minute detail by a team of artists. The overwhelming likelihood is that Henry of Blois (1096–1171), Bishop of Winchester and younger brother of King Stephen (d.1154), commissioned it.

When Henry died the impetus to complete the Bible stalled and its lack of use has meant that it is extremely well preserved. It has also left a second unique feature: a visible record of the different stages in the production of the illuminations, from the space in the manuscript to the completed initials. Sometimes the instructions for what an artist should put into the available space hidden in the margins. Stylistic differences show that the illuminations were sometimes designed by one artist and completed by another.

The four volumes of the Bible are now housed in the cathedral's award-winning Kings and Scribes display, in a chapel built when it was written. In preparation for the exhibition the Bible was rebound to allow its pages to fall and be turned more easily. The cathedral is proud to have a spiritual treasure as its most valuable possession – one which is still used for the installation of bishops and deans and which demonstrates the importance of treating the text of scripture as something to be valued and pondered.

RIGHT Illuminated initials from the Winchester Bible, now on permanent display in the Kings and Scribes display.

BELOW Winchester Cathedral from the west. The nave, though truncated in the 14th century, remains its most stunning architectural feature.

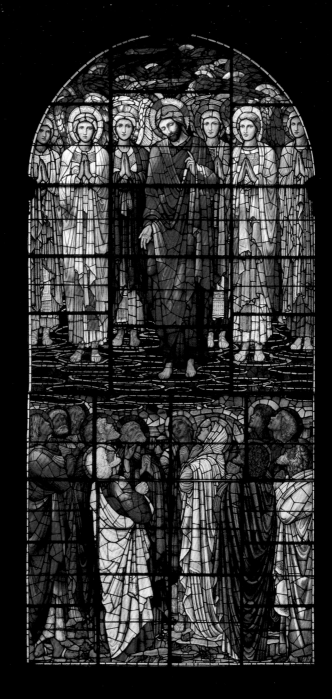

Church transformed by glorious Pre-Raphaelite vision

BIRMINGHAM CATHEDRAL

Ascension stained-glass window (1885)
DESIGNED BY SIR EDWARD BURNE-JONES AND MADE IN
THE WORKSHOP OF MORRIS & CO.

Stained glass, 5.8 x 2.74 m
www.birminghamcathedral.com 🐦 @bhamcathedral

TOWARDS THE END OF THE NINETEENTH CENTURY the parish church of St Philip, in the years prior to it becoming Birmingham Cathedral, underwent something of a transformation. Its simple, unadorned interior was extended to reflect changes in liturgical practice influenced by the Oxford Movement.

The crowning glory of these changes was a new monumental stained-glass window. It is a vast expanse of coloured glazing made of 21 separate panels, with no tracery or stonework to interrupt the scene. Sir Edward Burne-Jones (1833–1898) was the natural artist of choice. Not only was he the leading designer of stained glass of the day, but he was also a Birmingham native who had been baptised in the church.

The subject matter selected was Christ's Ascension, demonstrating a shift in focus to Christ's Resurrection rather than his Crucifixion. The completed window has two planes of activity, depicting heaven and earth. Both are filled with crowds of elegantly draped figures. The lower plane illustrates the disciples wringing their hands in concern as they witness their friend and teacher ascending to heaven. The upper area depicts a heaven where angels with serene expressions hover ethereally with a colossal stacking of fiery red wings behind them.

Burne-Jones and his collaborator William Morris (1834–1896) were benefitting from the development of new metal oxides for producing coloured glass, and the windows display a beautiful and radiant density of colour. Exquisite, hand-painted detail is apparent throughout the window; for example, in the tiny floral designs in Christ's halo, the intense facial expressions of the disciples and Jesus' softly outstretched palm beckoning his disciples – and us, as viewers.

LEFT On entering Birmingham Cathedral, the visitor's eye is immediately drawn to Sir Edward Burne-Jones's Ascension window at the East End.

BELOW Thomas Archer's classical church of 1708 had its apse extended in the 19th century, now displaying Burne-Jones's Nativity, Ascension and Crucifixion windows.

Poignant symbol of war and reconciliation

COVENTRY CATHEDRAL

High Altar Cross (1961)
GEOFFREY CLARKE (1925–2014)

Latin cross incorporating a cross of nails. Silver, gilded, 3 x 2.5 m
www.coventrycathedral.org.uk 🐦@CovCathedral

THE HIGH ALTAR CROSS BY GEOFFREY CLARKE holds a space at the (liturgical) East End of the new Coventry Cathedral, which was consecrated in 1962. At the heart of the sculpture is a cross of nails, formed in 1940 from three of the nails that fell from the burning roof of the original St Michael's Cathedral during the Coventry blitz. They speak of a Christ who is revealed most clearly in places of destruction, transforming them by faith into places of hope.

This cross was used in a 1962 pilgrimage around the Diocese of Coventry. People gathered in churches to pray for the new building, and on street corners to watch the cross pass by. Eventually it was brought into the cathedral and placed within Clarke's arresting sculpture, which some see as a bird, others as a dancer and yet others as a tree, rooted in the ministry of reconciliation.

Clarke contributed several artworks to Sir Basil Spence's architectural creation: the High Altar Cross was an inspired addition, but not without challenges. Silver and gold were hard to come by in the post-war years, and when the metal cross was brought to the cathedral Clarke immersed it in a tarpaulin strung between two trucks for electroplating, with whatever sources of silver and gold could be found. It was consequently refused an assay mark, and it requires repeated cleaning as the base metals leach through onto the surface, wholly blackening the sculpture every few years. This contributes to the sense that it is something alive, something which recognises the ongoing and never-finished task of reconciliation.

RIGHT Detail of the High Altar Cross: at its heart is the cross of nails.

BELOW Sir Basil Spence's dramatic and spiritual mid-20th-century Coventry Cathedral (nave looking east) incorporates contemporary artworks. Graham Sutherland's *Christ in Glory* tapestry dominates the nave.

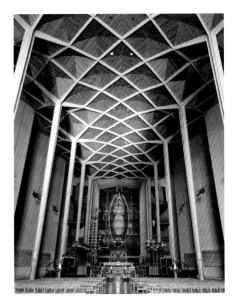

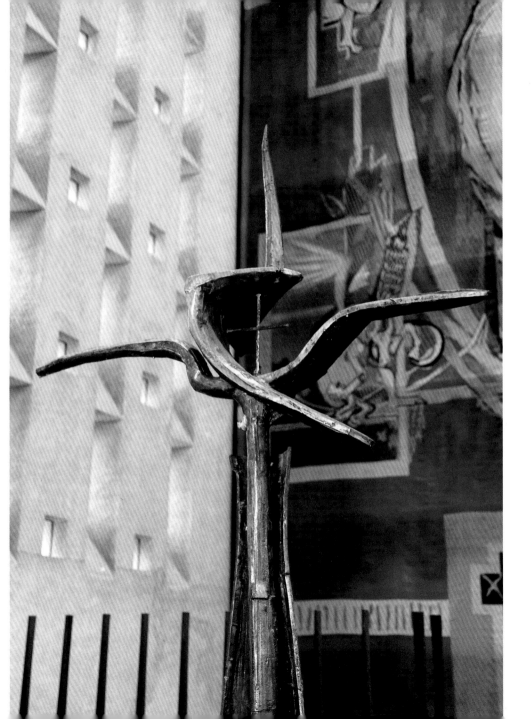

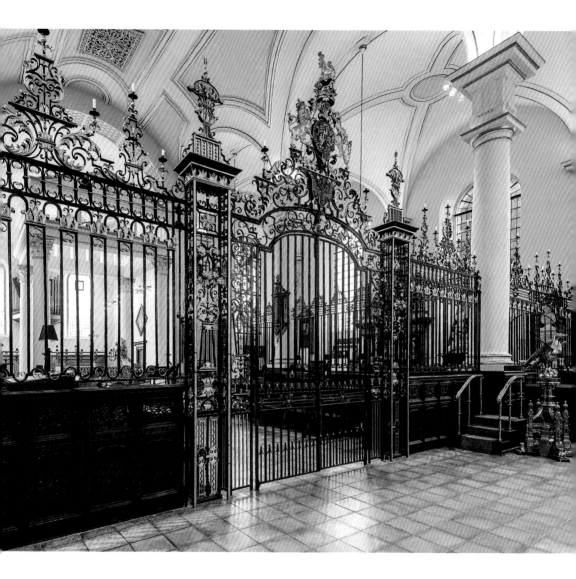

Masterpiece from the dawn of the Industrial Revolution

DERBY CATHEDRAL

Bakewell screen (commissioned 1722, installed by 1725)

Wrought iron (painted and gilded), extends the whole width of the cathedral, 25 x 5.2 m (highest point)

www.derbycathedral.org 🐦@DerbyCathedral

DERBY CATHEDRAL OCCUPIES A CITY CENTRE Anglo-Saxon site where Christians have worshipped for nearly 1,100 years. The early sixteenth-century Perpendicular tower and the cathedral's mid-twentieth-century extension are bridged by an Enlightenment nave which resonates with the values of the early Georgian period. The nave is notable for its expansive plain-glass windows, which symbolise the light of reason guiding humanity in the ways of God.

The nave was designed by the architect James Gibbs (1682–1754) in the neo-classical style. Across its whole width is a magnificent wrought iron screen, designed and manufactured by the Derbyshire master craftsman and ironsmith Robert Bakewell (1682–1752). The screen is described being as 'delicate as lace and as intricate as a fugue'. The screen's combination of beautiful filigree ironwork, scrolling acanthus leaves and an overall lightness of structure make it an exceptionally significant treasure. It was installed to separate nave and chancel without obscuring the view.

LEFT Robert Bakewell's 18th-century gilded and painted wrought iron screen extends the whole width of the cathedral.

BELOW Derby Cathedral with its 16th-century Perpendicular tower, James Gibbs' classical 18th-century nave and 20th-century retrochoir by Sir Ninian and Sebastian Comper.

The overthrow of the main gates carries the royal arms of George II (r.1727–1760). Despite having been altered and moved several times to suit the liturgical preferences of different generations, the screen's central section remains Bakewell's original work. Candle sconces are placed across the top of the screen so that candles can be lit to enhance the atmosphere of festive occasions.

The Bakewell screen links Derby Cathedral to the adjacent Silk Mill, recognised as being the site of the world's first mechanised factory. Here a pair of Bakewell gates – installed in the same era as the cathedral screen – stands at the entrance to what is now the Museum of Making, which opened in 2021 and celebrates Derby's three-hundred-year history of making to inspire new creativity.

The medieval Christian world view
HEREFORD CATHEDRAL

Mappa Mundi (*c*.1300)

White vellum, 1.58 x 1.30 m
www.herefordcathedral.org 🐦@HFDCathedral

THE HEREFORD MAPPA MUNDI WAS DRAWN in vibrant colours on a single sheet of white vellum. It has survived, intact but now sepia, for over seven hundred years. It is the largest existing medieval world map and one of the most remarkable pictorial thirteenth-century manuscripts anywhere. Created as a work of art, it has been a tourist attraction at Hereford Cathedral since at least 1330. Hereford itself is reduced to an indistinct smear, having been almost rubbed away over the centuries by the pointing fingers of excited pilgrims.

The Mappa still excites with its stories and wonderful pictures – it contains 420 towns, five scenes from classical mythology and 33 animals and plants – but it is a more profound achievement than that. Its depiction of the known world is unabashedly Christological. At the centre are Jerusalem and the Crucifixion. Christ sits in majesty at the top of the world, surveying all creation with wounded hands uplifted. On his right the saved rise from their coffins and enter the gates of heaven. On his left the damned are dragged towards the gaping mouth of a great beast symbolising the gates of hell. Alongside medieval cathedrals and seats of learning we find Babylon, Noah's ark and the winding route taken by the Israelites in the wilderness after the parting of a (literally) Red Sea.

The Mappa is a trove of theology, history and mythology, along with colourful guesswork about people, creatures and places beyond the medieval experience. It speaks profoundly of an almost lost mindset, but in offering a portal into a world in which Christ is at the centre, it is also a valuable teaching and missional resource today.

RIGHT Mappa Mundi (colours enhanced) on display in the Chained Library at Hereford Cathedral.

BELOW The statue of composer Sir Edward Elgar outside Hereford Cathedral – a great centre of pilgrimage in medieval times. The cathedral has played host since the 18th century to the Three Choirs Festival, together with Gloucester and Worcester cathedrals.

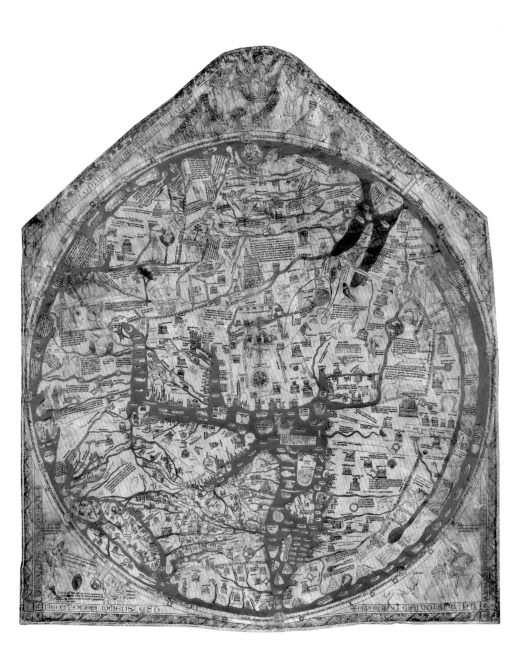

Richard III: reburial and redemption

LEICESTER CATHEDRAL

Redemption windows (2016)
THOMAS DENNY (b.1956)

Two stained-glass windows, 3.45 x 2.03 m
www.leicestercathedral.org @LeicsCathedral

KING RICHARD III (r.1483–1485) died at the Battle of Bosworth on 22 August 1485. Five hundred years later his remains were discovered in a Leicester car park that was once the site of a Franciscan friary. Richard was reburied in the cathedral in March 2015. The congregation included both Yorkists and Lancastrians whose ancestors had fought in the battle.

The Chapter commissioned Thomas Denny to design and make two new north-facing windows for the chapel of St Katharine, which sits adjacent to King Richard's tomb. The windows were installed in 2016, just as Leicester City Football Club won the premiership. Denny consequently included a football in his design.

These Redemption windows explore themes of reconciliation using vignettes from the life of Richard III, in combination with biblical stories. Richard is portrayed not only as someone rooted in the Wars of the Roses (1455–87), but also as an archetype for all people.

Denny says: 'This project has engendered in my imagination a much more profound sense of history as being something animate in contemporary life. The themes of life and death and resurrection, of history and of the sacred, have become seamlessly mingled'.

The windows were made using traditional methods and are rich in colour and painterly detail. We see Richard as a child, as a confident young man, as battle-clad, as broken following the deaths of both his son Edward (1473–1484) and his wife Anne (1456–1485). Ultimately he is defeated, slung over the back of a horse on bloody Bosworth field. All this is suffused with the radiant presence of Christ, revealed on the road to Emmaus and in the encounter with sinners in need of redemption.

LEFT The 2012 discovery in the city centre and reburial of Richard III in Leicester Cathedral brought medieval history alive for many. Thomas Denny's gorgeously coloured Redemption windows adopt a reflective approach and reward careful examination.

BELOW Richard III stands bereft following the death of both his son and wife. The scene echoes the beginning of Dante's *Divine Comedy*, in which a man is lost in a shadowed forest.

Angel in waiting: hidden for nearly a millennium

LICHFIELD CATHEDRAL

Lichfield Angel (*c*.800)

Limestone, H. 63.5 cm, W. 37 cm, D. 10 cm

www.lichfield-cathedral.org 🐦@LichfieldCath

THE LICHFIELD ANGEL DEMONSTRATES the ambition of King Offa of Mercia (757–796) to rival the achievements of Charlemagne (r.768–814). When this amazing object was discovered under the floor of the nave in 2003, it changed our understanding of Saxon sculpture. Its three pieces had lain undisturbed for nearly a thousand years, face down, partially over air pockets so that the carving was little affected by damp or abrasion. Other survivals had usually to contend with the weather, or at least with daylight and human attention. Suddenly we could all see what the Saxon carvers were capable of in terms of the delicacy and imagination of their work.

The Lichfield Angel is thought to be the left-hand half of an Annunciation, and therefore to be missing the figure of the Virgin. It represents the Archangel Gabriel, carrying his staff as messenger to the Virgin. He was originally coloured, and traces of paint survive in some places (again a rarity with sculpture of the period). The figure was red against a white ground, with a white halo edged in ochre (possibly as a base for gold leaf). The feathers on the angel's wings were red at the base and white at their tips.

The sculpture clearly forms part of one end of a box-like structure, most probably a shrine chest. It is tempting to identify it with an early shrine to St Chad (d.672). Chad's first shrine was described by the Venerable Bede (*c*.731) as a wooden structure, but this limestone could perhaps have replaced that and served until (so the excavation evidence tells us) it was buried shortly before the Norman Conquest.

RIGHT The Lichfield Angel (*c*.800) and earlier (8th-century) Chad Gospels are on display in the Chapter House at Lichfield Cathedral.

BELOW Lichfield Cathedral with its three medieval spires intact. One spire was repaired after it was blown up in the Civil War.

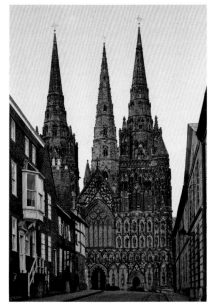

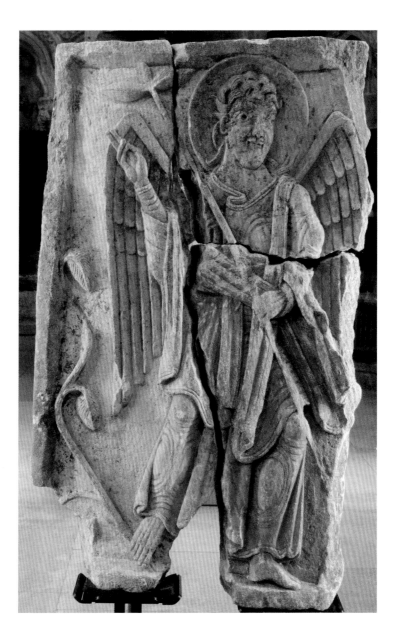

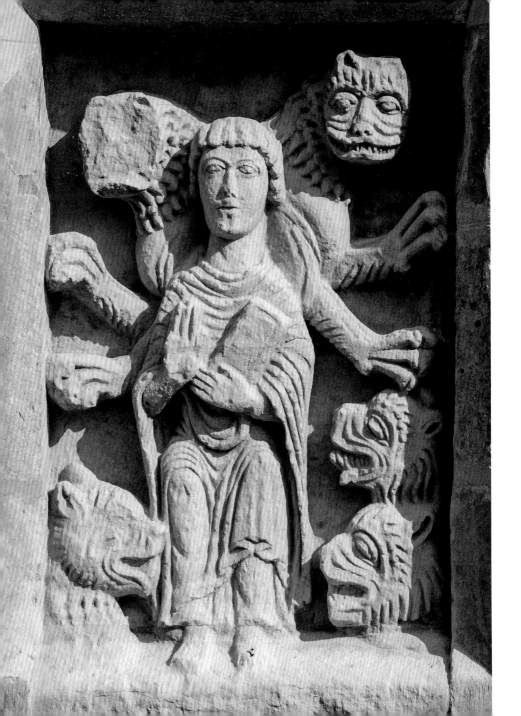

Panorama of Bible scenes crafted in limestone
LINCOLN CATHEDRAL

Romanesque frieze (*c*.1120–1160)

Limestone, 17 carved panels L. 16.1 m, H. approx. 1.1 m (each panel)
www.lincolncathedral.com @LincsCathedral

THE ROMANESQUE FRIEZE – A BAND OF STONE PANELS across the cathedral's West Front – dates from the first half of the twelfth century. The panels depict scenes from stories in the Old and New Testaments. The first set of panels warns people of the dangers of sin, but with the prospect of rescue from the threat of Hell. The second set deals with salvation. The frieze is likely to have been commissioned by Alexander the Magnificent, who was Bishop of Lincoln from 1123 to 1148.

The extraordinary quality of the craftsmanship that went into creating the frieze, which was originally painted in an array of colours, can still be appreciated. It is thought that there were at least four further panels in the frieze, but these are now missing, removed when alterations were made to the West Front in the fourteenth century. While not all the original panels survive, the frieze is still one of the most important examples of relief carving from the first half of the twelfth century in western Europe.

Today nearly half of the original panels, which are made from locally sourced limestone, remain on the West Front. The others are displayed inside the cathedral's Exhibition Gallery to ensure their preservation. The northern run of panels was severely damaged by iconoclasts in the sixteenth or seventeenth century. Beautifully carved copies by John Roberts and Alan Micklethwaite were installed on the West Front to provide a better sense of the original appearance of the complete frieze, with missing areas reconstructed. The southern run of panels on the West Front consists of original panels, with one badly damaged original being taken for display in the Exhibition Gallery.

LEFT Daniel in the lions' den from the Romanesque frieze after complex repairs, conservation, cleaning and a shelter coat treatment, completed 2022.

BELOW The newly revealed Romanesque West Front of Lincoln Cathedral. Based on Constantine's triumphal arch in Rome, it contains the Romanesque frieze in 17 panels, set 8 metres above the ground.

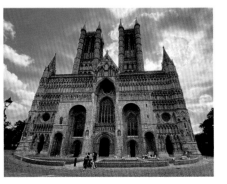

Flowering of naturalistic craftsmanship

SOUTHWELL MINSTER

Leaves of Southwell (1290s)

Stone carvings of the capitals, vault and walls of the Chapter House, Mansfield stone; decorating vestibule
and octagonal Chapter House 10 x 10 m; approx. height of blind arcade 1.86 m
www.southwellminster.org 🐦@SouthwMinster

SIR NIKOLAUS PEVSNER FAMOUSLY wrote his monograph *The Leaves of Southwell* in 1945, describing in detail the exquisite naturalistic stone carvings of animals, leaves and mythical creatures all around the Chapter House. Dating from the end of the thirteenth century, they are a fine example of the English Gothic style and are recognised as being of international significance. The skill, ingenuity and powers of observation of the medieval stone masons mean that these decorated carvings are unrivalled in England, and no less important than those found in Rheims and Naumburg.

A major project of conservation and repair, completed in 2022, has afforded new insights into to how and why these superbly decorated stone carvings came to be in this small market town in Nottinghamshire, once home to the Archbishops of York. Could the splendid octagonal Chapter House reflect nearby Sherwood Forest, where the natural world bursts with vitality? How do the Leaves speak to us seven centuries later of harmony and fragility in God's creation, providing insight as we counter climate emergency? Perhaps they are a meditation on Psalm 1, which invites us to wise living:

> And he will certainly become like a tree
> planted by streams of water,
> That gives its own fruit in its season
> And the foliage of which does not wither,
> And everything he does will succeed.

The adjacent Palace Gardens complete the visitor's experience, with exploratory trails tracing the new planting of all the species found in the Chapter House.

RIGHT Vigorously carved plants decorate the capitals in the Chapter House at Southwell – vine leaves and grapes, oak leaves and acorns.

BELOW The Leaves also fill the bosses in the vaulted octagonal Chapter House.

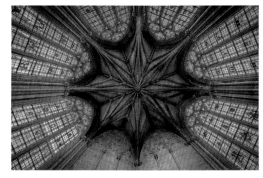

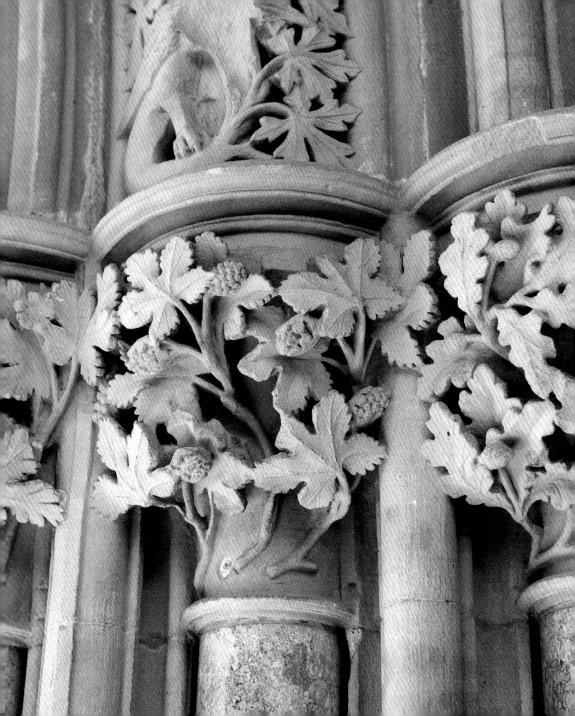

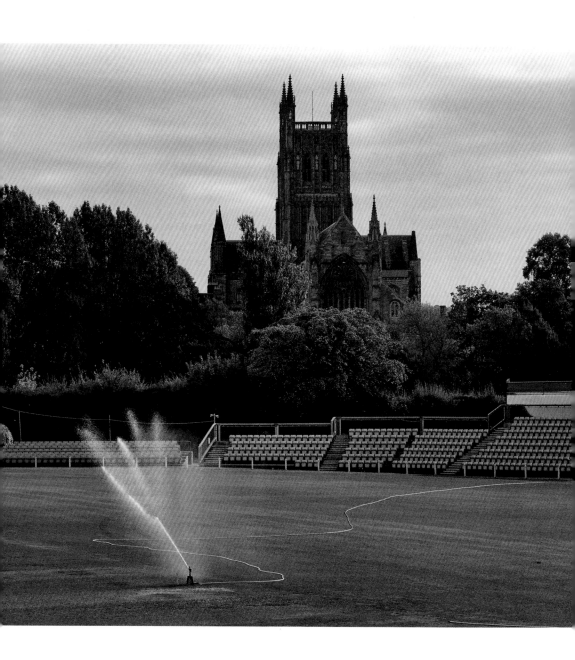

Rare survivals from a pilgrim's grave

WORCESTER CATHEDRAL

Pilgrim boots (*c.*1480s–1510)

Cowhide boots, wooden staff and cockleshell pilgrim badge (traditional emblem of St James) of a medieval pilgrim; boots: H. 51 cm, diam. 10 cm; staff: 156 cm

www.worcestercathedral.co.uk 🐦@WorcCathedral

IN 1986 A RARE BURIAL WAS DISCOVERED during excavation works in Worcester Cathedral. It revealed a body wearing knee-length boots, patches of woollen clothing, a wooden staff and a horn badge in the shape of a cockleshell. Earlier building work had disturbed it and the skull was missing.

There was no coffin, but there is evidence suggestive of a shroud. Dated between 1374, when the tower was rebuilt, and 1540, when the monastery was closed, the body was that of a man in his sixties or older. His height was estimated at 5 ft 7.5 in. His skeleton showed signs of muscle usage typical of someone who walked or who was active earlier in his life. The pilgrim was reburied in the cathedral on 6 February 1999.

LEFT View of Worcester Cathedral from across Worcestershire cricket ground.

BELOW Medieval pilgrimage takes on greater immediacy in these well-preserved pilgrim boots.

His knee-high cowhide boots were dated stylistically to between the later 1480s and *c.*1510. The cockleshell badge could have been collected at one of many different locations in Britain or Spain. The staff was analysed and found to have been covered in a purple dye.

The pilgrim's identity is unknown. Robert Sutton (d. pre-1457), a local dyer and city bailiff, or cathedral sacrist John Clyve, who went on a pilgrimage to Santiago de Compostela in 1428, have both been considered, in spite of their dates.

In 2014, the crypt display of the pilgrim's staff, boots and badge was redesigned. It can be viewed by the public together with new display panels in the south aisle of the crypt originally built by St Wulfstan (*c.*1008–1095) in 1084. The crypt is a worthy resting place for these treasures and a peaceful location for modern-day pilgrims to enjoy.

Allegory of destruction and renewal

CHELMSFORD CATHEDRAL

The Tree of Life painting (2003–2004)
MARK CAZALET (b.1964)

Painting on 35 birch wood panels, H. 6 m
www.chelmsfordcathedral.org.uk 🐦@CCathedral

CHELMSFORD CATHEDRAL IS A LIGHT and airy worship and community space, reordered dramatically in the early 1980s. Over the last 30 years it has become well known for its collection of contemporary Christian art, commissioned specifically for the cathedral.

The Tree of Life by Mark Cazelet is the most significant intervention, filling as it does the entire tracery of a formerly blank window in the high gable wall of the North Transept. The painting is based on a large tree in the cathedral close and has at its heart an invitation to reflect on humanity's impact on the environment. The design is intentionally symmetrical. On the left-hand side, we are presented with a scene of environmental devastation and catastrophe. The tree of life is dying, and the dramatic figure of Judas hangs from the branches. On the right there is new creation – the wheat grows in the fields and St Cedd, the great Celtic missionary of Essex in the seventh century, stands at the foot of the tree welcoming two children who represent Adam and Eve. Most startling perhaps is a living, resurrected Judas high up in the tree with sandwiches and a thermos – the artist's favourite feature of the painting – holding out the promise of full forgiveness, renewal and new life.

The Tree of Life also represents an important aspect of the cathedral's vision and mission. Chelmsford is only the second cathedral to be awarded gold in the A Rocha Eco Church award scheme. It maintains a serious commitment to sustainability, part of the Church's wider commitment to addressing climate change and biodiversity crises.

RIGHT Artist Mark Cazalet explains *The Tree of Life* using symbolic language to invite open-ended readings which might shift over time like the natural cycles of spring to winter. The tree is vigorous and so should we be in our praise and self-giving lives.

BELOW Detail of the resurrected Judas at top right, diagonally above his hanging. The tree is also full of birds and butterflies leading plant-based lives.

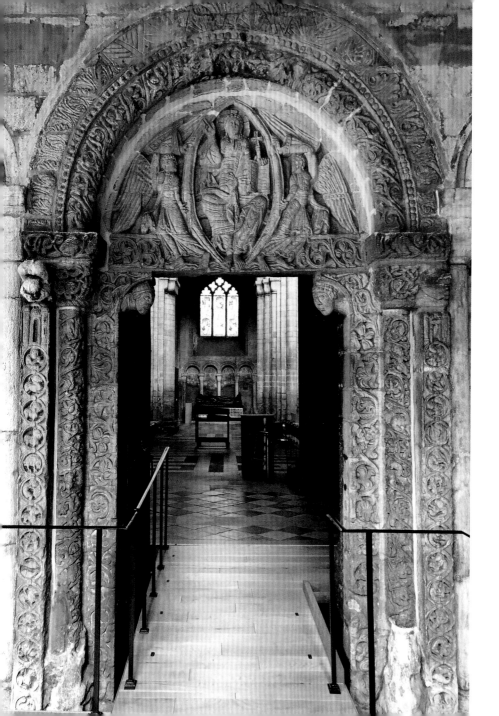

Gateway to heaven
ELY CATHEDRAL

Prior's door (*c.*1135)
Barnack limestone, 2.3 x 2.45 m
www.elycathedral.org @Ely_Cathedral

LEFT The Romanesque or Norman Prior's door, with adjacent Monks' door, is a rare survival of Ely's cloister and pre-Reformation monastic buildings.

BELOW Romanesque West Front of Ely Cathedral with blind arcading. The north-west tower and transept collapsed in the 15th century.

THIS MAGNIFICENT ROMANESQUE CARVED doorway dates from the early twelfth century. It was most likely completed by 1135 and was part of the building of the Norman church (*c.*1081–1189). It opens off the medieval cloister, but, despite its name (acquired in the nineteenth century), it was not built for the use of the Prior; it is likely instead to have been used by the monastery's important secular visitors.

Like the rest of the building, the deeply carved doorway is sculpted in extremely hard Barnack limestone. It has a tympanum – a half-moon shape at the top – which would originally have been brightly painted. It shows an unusual clean-shaven Christ sitting in judgement on the peoples of the earth. One hand is raised in blessing, the other holds the Book of Judgement from Revelation.

The Christ figure is contained within a mandorla – an almond shape traditionally used to frame images of the transcendent. Here Christ's feet cross the boundary of the mandorla, stepping towards mankind.

The doorway has three intricately carved jambs on each side. The inside jambs are covered with stylised foliage, the middle ones with a detailed interlace design, including 'biting beasts' reminiscent of the Viking era; there are roundels on the outside jambs showing, on the western side, signs of the zodiac and, on the eastern side, vignettes of human activity. Two human heads with pronounced eyes just below the tympanum watch those passing through the door into the church and symbolically entering heaven.

Ancient stones rooted in Judeo-Christian tradition

NORWICH CATHEDRAL

Bishop's throne (Anglo-Saxon stones from pre-Conquest throne)

Modern wooden throne; limestone fragments of earlier throne; north stone 60 cm, 20 cm, H. 71 cm, south stone 46 cm, 20 cm, H. 23 cm

www.cathedral.org.uk @Nrw_Cathedral

SET AT THE CURVED EAST END OF THE CATHEDRAL, it is often said of this apsidal throne that it is the only survival of a bishop's seat in this basilican position in northern Europe. To recognise its rarity, however, is only to scratch the surface of its resonance and power.

The origin of the throne reaches back to the Jewish Tent of Meeting and the Temple in Jerusalem, where the mercy seat on the Ark of the Covenant was understood to be the throne of God and the locus of God's presence with his chosen people. On Yom Kippur, the Day of Atonement, the high priest would sprinkle the mercy seat with the blood of sacrifice, signifying the covering of the people's sin.

The throne of God in the heavenly temple was translated into Christian worship, envisaged most powerfully in the Book of Revelation, which inspired the cathedral sanctuary. The worship of heaven is focused on the throne of God and of the Lamb on an apse – with the altar before it, the elders around it and the 'sea of glass' beneath it in the form of the mosaic pavement.

The heavily burnt pre-Conquest stone fragments beneath the seat are associated with an earlier throne of the bishops of East Anglia. Inspired by the disposition of the tomb of the apostle in Old St Peter's, the throne platform is connected by a flue to a reliquary niche below. The niche was created to enshrine the relics of St Felix, the seventh-century founding bishop of the diocese.

RIGHT A modern bishop's throne sits over stone remains of the former Anglo-Saxon throne.

BELOW The Bishop of Norwich at his throne during a service, significantly in the position most common in early churches and derived from the Roman tradition.

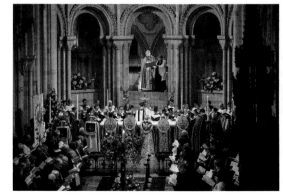

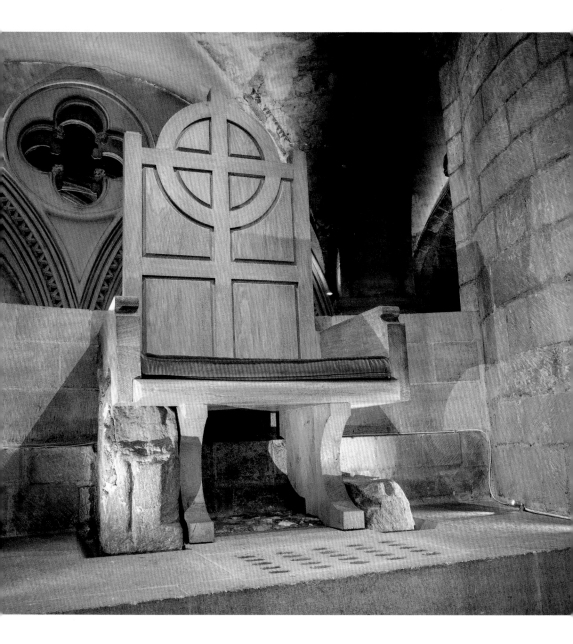

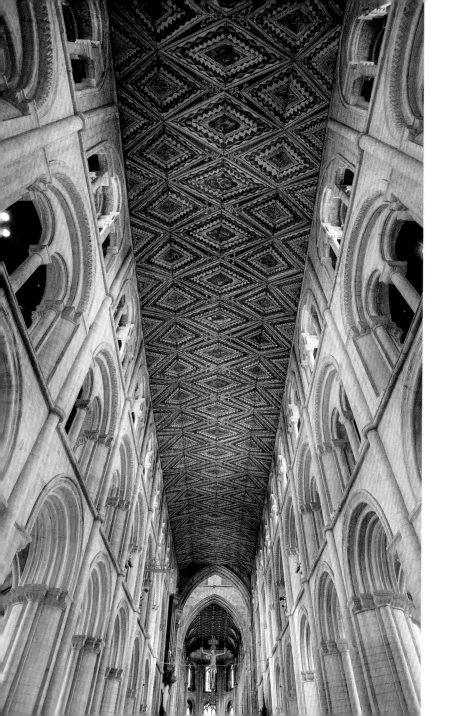

Remarkable decor from the thirteenth century

PETERBOROUGH CATHEDRAL

Nave ceiling (*c.*1240–1250)

Painted wood, L. 62 m, W. 11 m

www.peterborough-cathedral.org.uk 🐦 @pborocathedral

LEFT The nave ceiling at Peterborough Cathedral – 'the greatest surviving polychrome work of art in the whole of medieval England' – Jonathan Foyle.

BELOW The figure of Geometry, one of the seven Liberal Arts, reads like a latter-day architect in a painted lozenge in the ceiling.

THE NAVE CEILING IN PETERBOROUGH CATHEDRAL is the largest painted ceiling of its age in Europe. The viewer beholds a series of 57 lozenge shapes depicting all manner of figures. Some of them are kings, bishops or archbishops – possibly the ones who were alive during the 120 years it took to complete the great abbey church of St Peter. The seven Liberal Arts (music, geometry, logic, grammar, rhetoric, arithmetic and astronomy) are depicted, and there are images of saints such as Peter and Paul.

Some of the lozenges are difficult to interpret. The image of a monkey riding backwards on a goat while talking to an owl is not one that speaks easily to the modern mindset (it may be that it is a depiction of folly). In addition to the Lamb of God (the *Agnus Dei*) we can see Luna (the moon) in her chariot, the devil and Janus with his two faces. These strongly contrasting figures have led some to speculate that the ceiling is an extended metaphor concerning good and evil.

The great ceiling has survived fire and civil war. Today, thanks to electric lighting and a thorough effort at conservation at the beginning of this century, can perhaps be seen more clearly today than ever before.

Christ's agony captured in bronze

ST EDMUNDSBURY CATHEDRAL

Crucifixion sculpture (1983)
Dame Elisabeth Frink (1930–1993)

Bronze, 71 x 73 cm

www.stedscathedral.org @stedscath

This bronze figure of *Christ Crucified* floats against the wall of the Chapel of the Transfiguration. The metal is worked and pitted with a rugged effect typical of the sculptor Dame Elisabeth Frink, whose lifelong fascination with the male figure receives a tender treatment in this small sculpture. Her characteristic rawness of surface accentuates the cruelty of crucifixion, but the gaunt figure projects nobility of spirit through the physical tension.

Frink was born in Thurlow, and much of her sculpture recalled her early days in the Suffolk countryside. In 1976 Suffolk County Council commissioned from her the statue of St Edmund which stands on the green on the south side of the cathedral.

An edition of six copies of *Christ Crucified* was made in 1983. This sculpture was the artist's copy and was hung in the cathedral in 1995 as part of a Frink trail in Bury St Edmunds. Frink's son agreed to sell it to the Friends of St Edmundsbury Cathedral after her death.

The Chapel of the Transfiguration is a tranquil space, full of light and peace. It was consecrated in 2009, having been designed by the architect Stephen Dykes Bower (1903–1994) and completed as part of the Millennium Project for the cathedral buildings.

Right Elisabeth Frink's crucifixion statue hangs in the moving, unadorned Chapel of Transfiguration (2009) designed by Stephen Dykes Bower.

Below detail: head of *Christ Crucified*

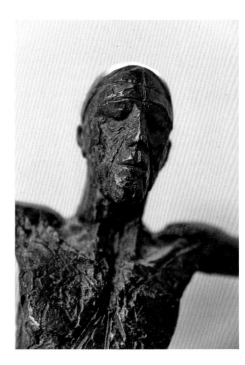

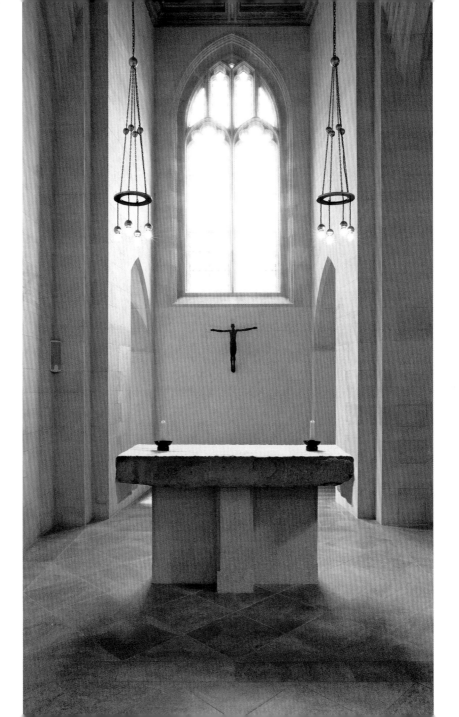

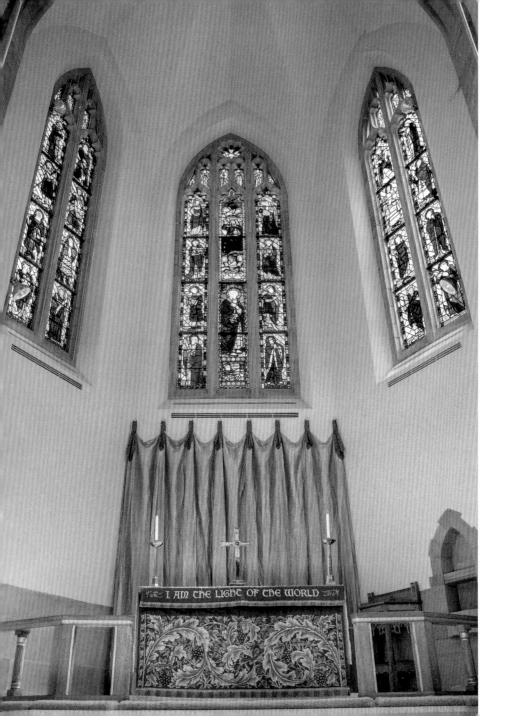

Showcase of Pre-Raphaelite artistry

BRADFORD CATHEDRAL

Early Morris & Co. windows (1863 and 1864) *and altar frontal* (1880s)

Stained glass, H. 5.4 m, W. 1.25 m (north and south windows), 1.87 m (central); embroidered silk, L. 2.07 m, H. 1 m

www.bradfordcathedral.org 🐦 @Bfdcathedral

BRADFORD CATHEDRAL COUNTS AMONG ITS TREASURES handsome Morris & Co. windows situated in four locations in the building. These were originally two windows that were inserted in 1863 and 1864, with the 1863 window being only the Company's third ever commission in stained glass.

During extension work in the 1960s, the glass from 1863 was painstakingly moved to its present location in the Lady Chapel. The stunning designs for these saints' windows are by William Morris, Dante Gabriel Rossetti (1828–1882), Sir Edward Burne-Jones, Peter Paul Marshall (1830–1900), Ford Madox Brown (1821–1893) and Philip Webb (1831–1915). There is also a recently discovered design by William De Morgan (1839–1917), with St Mark having been previously attributed to Burne-Jones.

The glass from 1864 can now be seen in the North Ambulatory and North and South Transepts. The eye-catching central figure of the original window, Salvator Mundi, was designed by the architect Albert Moore (1841–1893), while the distinctive angels are Morris's work. The martyrs pictured in the transepts are by Morris, Burne-Jones and Ford Madox Brown.

Bradford Cathedral also has an intricate Morris & Co. altar frontal. This precious object was found in a drawer in the sacristy in 2005, having not been seen by anyone connected with the cathedral in living memory. It has been verified as a hand-embroidered Morris design by the Victoria and Albert Museum. After restoration in 2016 the altar frontal was placed in the Lady Chapel, beneath the Morris & Co. windows, for all to enjoy.

LEFT The inspired reunion in the Lady Chapel of highly significant work by Morris & Co.

BELOW Bradford Cathedral is at the heart of the UK City of Culture 2025.

Potent symbol of protection
DURHAM CATHEDRAL

Sanctuary ring (12th century)
Bronze, head diam. 55 cm, ring diam. 24 cm, 30 kg
www.durhamcathedral.co.uk 🐦 @durhamcathedral

St Cuthbert's shrine was not only a place of pilgrimage, but also a refuge for those seeking sanctuary. Fugitives who grasped the Sanctuary ring on the cathedral door were given 37 days' protection from the law before having to choose between facing trial or going into exile. The right of sanctuary continued at Durham until 1624.

The Sanctuary ring currently on the north door is a replica, placed there in 1980. The original is now in the Durham Cathedral Museum. It was made at around the same time as the north door, though some researchers have suggested that it was commissioned and made before the door was completed. It is often referred to as a 'knocker', but it does not in fact knock. The sanctuary seeker only had to touch it to claim refuge.

The striking design of the ring was intended to frighten away evil. It suggests a hellmouth: there is a similar image in the Winchester Psalter, which dates to around 1150. Durham's Sanctuary ring shows the face and mane of a lion who is eating a man. The man's legs hang out of the lion's mouth and a double-headed snake bites his feet, forming the handle.

The ring remains immensely popular with visitors. Along with the Pectoral Cross of St Cuthbert, it is seen as a symbol of the cathedral and of Durham.

RIGHT The original Sanctuary ring is in Durham Cathedral Museum in the former monks' dormitory and kitchen alongside the Pectoral Cross and other personal possessions of St Cuthbert (d.687)

BELOW the mighty Norman cathedral towers over the River Wear and is now part of a World Heritage Site.

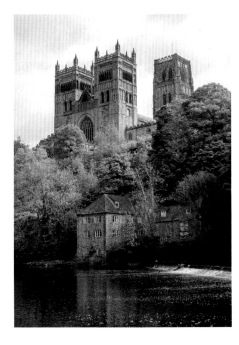

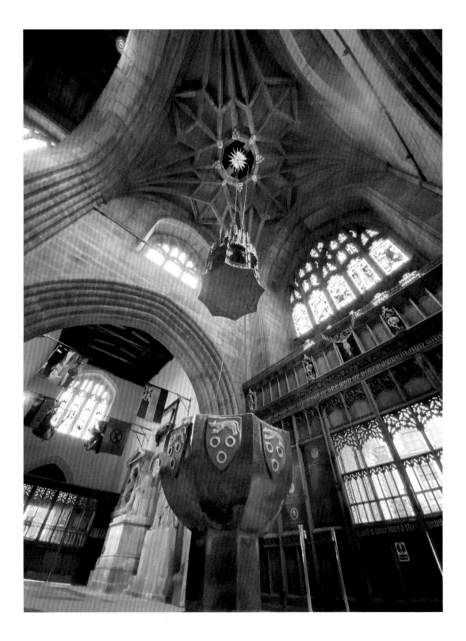

Serene treasure with a turbulent story
NEWCASTLE CATHEDRAL

Font and font cover (15th century)

Limestone and Frosterley marble with carved oak cover, H. 45 cm, diam. 87 cm

newcastlecathedral.org.uk 🐦@nclcathedral

AT THE WEST ENTRANCE TO THE CATHEDRAL, one finds oneself beneath the lofty dome of the lantern tower. Strong clustered columns support the tower, forming a beautiful, fanned ceiling. Surrounded by coats of arms of the Rhodes family, a dove hovers at the apex of the vaulting. Robert Rhodes was a great benefactor in the city and was MP for the town seven times between 1427 and 1442.

Below, at the centre, is the fifteenth-century font, a simple but elegant basin. It is carved from limestone, possibly from Tournai in Belgium. Surrounding its base is a delicate stone leaf design, inlaid with Frosterley marble. Above it hangs a carved medieval oak cover. Its intricate design contains an almost hidden boss of the Coronation of the Virgin. The cover no longer hangs directly over the basin due to the (well-monitored) movement in the tower. Inside the font is a beautiful plain copper bowl discretely lit from beneath – full to the brim with water that gently pours over the sides.

LEFT Directly under the open lantern tower, the 15th-century font welcomes visitors to St Nicholas's Cathedral, Newcastle.

BELOW The oak font cover illustrating the boss of the Coronation of the Virgin.

Though the font has stood in its present place for many years, it has not always been safe here. It was unused in the nineteenth century, but long before that its very survival had to be secured by a quick-thinking local mason called Cuthbert Maxwell. Soon after entering the town in 1640, an attacking Scottish army destroyed the font in nearby St John's Church. Maxwell rushed to St Nicholas (now Newcastle Cathedral) and took its font apart. He hid the pieces in the vestry, where they secretly remained until 1660. He then re-erected it, ensuring that it lived on for thousands more baptisms.

Links to Rome in design and stone

RIPON CATHEDRAL

Crypt of St Wilfrid (*c.*672)

Roman stone, central chamber 3.5 x 2.4 m
www.riponcathedral.org.uk @riponcathedral

RIPON CATHEDRAL CRYPT, DATING FROM AD 672, has the distinction of containing the oldest built fabric of any English cathedral. It was built as the crypt of the stone basilica erected by St Wilfrid as the centre of his monastery at Ripon. It survived the burning of Wilfrid's basilica in 948, and every subsequent church built above it has been constructed with this holy place at its heart.

Wilfrid (born *c.*634) travelled to Rome in the mid-650s, where he absorbed Roman traditions of learning, liturgy and architecture. In the early 660s the sub-king ruling in the southern part of the kingdom of Northumbria granted Wilfrid the monastery at Ripon and, in 664, supported him as chief spokesperson of the Roman party at the Synod of Whitby. Soon after Wilfrid began the transformation of the monastery – originally established in the 650s as a Celtic foundation – into a thoroughly Roman-style community. The basilica and crypt, dedicated to St Peter, was his signature building, echoing the great, basilica-style churches that Wilfrid had seen in Rome, many with catacombs beneath. Following practices he had observed on his travels, it was built with Roman stone, in this case brought from nearby Isurium Brigantum (modern Aldborough).

Wilfrid's crypt echoes the then still quite new continental model of a one-way devotional route, with catacomb-like corridors leading in and out of the small, barrel-vaulted chamber where holy relics were housed. It was designed to be a place of pilgrimage and prayer, and so it remains today.

RIGHT The Dean of Ripon continues a devotional tradition in the Anglo-Saxon crypt of St Wilfrid's original monastery.

BELOW Ripon Cathedral, at over 1,350 years old, is one of England's earliest Christian foundations. Here we see its powerful Early English Gothic West Front, dating from the 1260s.

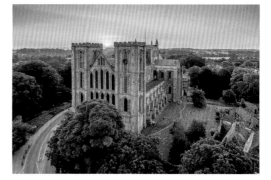

Carved oak seat featuring Talbot dogs
SHEFFIELD CATHEDRAL

Sedilia (15th century)

Oak, carved, H. 2.05 m, W. 2.3 m, D. 0.5 m
www.sheffieldcathedral.org @sheffcath

LEFT Rare wooden sedilia associated with the Talbot family, the Earls of Shrewsbury.

BELOW Talbot dogs are carved on the sedilia and appear carved and as graffiti elsewhere in the cathedral. This dog rests with the 1st Earl of Shrewsbury on his tomb.

IN MEDIEVAL CHURCHES SEDILIA were often provided as seats for the clergy officiating at mass: the priest, deacon and sub-deacon. Typically made of stone, they are usually set into the south wall of the sanctuary, with the seat for the priest being the nearest of the three to the altar. In England there are only four wooden sedilia in parish churches or, as in the case of Sheffield, in a cathedral which was originally a parish church.

Standing in St Katharine's Chapel, the Sheffield sedilia was constructed from oak in the early fifteenth century. The chapel in which it can now be seen was built in the late eighteenth century; the sedilia's original position is unknown, as are its origins. There may be a clue, however, in the depictions of Talbot dogs which appear on the sedilia. The symbol of the dog is forever associated with the Talbot family: Earls of Shrewsbury and, from 1407 until 1616, Lords of the Manor of Sheffield.

The first Talbot to be Lord of Sheffield was John, 1st Earl of Shrewsbury, who acquired the manor upon his marriage in 1407 and held it until his death in 1453. The then-parish church was rebuilt in *c.*1430, and so it may be that the Earl gave this sedilia to the newly rebuilt church. Talbot was a valiant and ruthless commander in the Hundred Years' War (1337–1453), but the gift of the sedilia may indicate some unexpected piety on his part.

Tender modern icon of motherhood

WAKEFIELD CATHEDRAL

Madonna and Child (1980)
Ian Judd (b.1947)

Stone sculpture, H. 1.73 m on 68 cm² base
www.wakefieldcathedral.org.uk 🐦 @WakeCathedral

At the heart of the fifteenth-century Lady Chapel at Wakefield Cathedral is a stone sculpture of the *Madonna and Child* by the artist Ian Judd. Judd, based in Halifax, Yorkshire, is well known for his monumental sculptures in stone, bronze and even concrete, most notably the Angel of Peace on Leeds War Memorial and the statue of J.B. Priestley in Bradford. But the *Madonna and Child* is one of his finest and earliest works, having been undertaken within a few years of Judd taking up sculpture in 1980.

Completed in 1986, the original concept was developed and worked up in polystyrene and then experimented on within the space of the Lady Chapel so that the size, proportions and modelling would be correct. The maquette still survives in the artist's studio.

The seated figure of Mary grows out of the base of the sculpture and gently cradles the Infant Jesus, who is wrapped in roughly textured cloth. The imagery of the young, almost vulnerable, loving mother and the defenceless child, clearly clad in poor quality cloth, provokes thoughts of the first Christmas and of the birth of Christ in a lowly stable with few comforts.

The contrast of smooth and rough textures invites visitors and pilgrims to touch the sculpture and interact personally with it. Today the *Madonna and Child* is a significant focus for reflection and devotion within the cathedral, with many from Wakefield and beyond deeply valuing the message it portrays.

RIGHT Ian Judd's *Madonna and Child*, with a patina developed by the touch of modern pilgrims' hands.

BELOW The nave at Wakefield Cathedral with 17th-century font and new Yorkshire stone floor with underfloor heating and an inlaid labyrinth.

The cosmopolitan and Christian side of the York Vikings

YORK MINSTER

Horn of Ulf (11th century)

Elephant tusk, L. 75 cm, W. 11.8–13.1 cm (at mouth)

Silver mounts (17th century)

www.yorkminster.org @York_Minster

LEFT the Horn of Ulf reminds us of the Viking influence over much of the country in early medieval times, as well as trading and cultural links across Europe and beyond.

BELOW The great east window of York Minster, seat of the Archbishop of the Northern Province, dates from 1405–8. It is the largest expanse of medieval glass in the world.

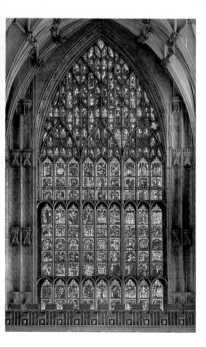

THE HORN OF ULF IS an eleventh-century oliphant (a horn carved from elephant tusk). It is said to have been presented to the cathedral in *c.*1030 by a Norse nobleman named Ulf as a horn of tenure, representing the lands and property he was giving to the cathedral. Later, King Edward the Confessor (r.1042–1066) confirmed the land transfer. The oliphant is intricately carved with plant and animal motifs: a lion preys on an antelope or deer, while a unicorn and other mythical beasts pace round the rim. Although documentary evidence is scant, by tradition Ulf is said to have placed the horn – filled with wine – on the altar, and to have dedicated his lands to God and to the Church of St Peter in York.

The Horn of Ulf was probably made in southern Italy, in or around Salerno or Amalfi, which had strong trading connections with Africa and with the Islamic world. The design of its carved decoration was evidently influenced by this exchange of artistic ideas.

The horn has been modified over time. A gold chain was added in 1393, only to be lost when the oliphant was removed from the Minster (probably during the Reformation). The horn was returned in 1675 by Henry Fairfax, a prominent local nobleman, and its silver mounts were added around the same time. Today it is on display with many other incredible treasures in York Minster's Undercroft Museum, which also reveals the Roman history of the site and the Saxon origins and later evolution of the cathedral.

Miniature token of the peace
BLACKBURN CATHEDRAL

Pax (15th century)

Gilded brass or latten (copper/zinc alloy), 7 x 5 cm
www.blackburncathedral.com @bbcathedral

ALTHOUGH CHRISTIAN WORSHIP HAS taken place on the site of Blackburn Cathedral since the sixth century, there are few traces of its early history. The present building is firmly rooted in the modern age, with its collection of contemporary art, striking lantern tower built in 1977 and mission reflecting the fast-changing demographic and character of the county.

However, a glimpse of pre-Reformation life can be seen in a rare fifteenth-century pax. This is a small gilt tablet, approximately 7 cm tall and 5 cm wide, engraved with the Virgin Mary holding the Infant Jesus and standing on a crescent moon. It would have been kissed by priest and congregation as a means of exchanging a sign of peace during the Mass. Almost all of these tablets were destroyed during the Reformation and only eight are known to have survived in this country.

The early Christians did kiss each other, but by the thirteenth century concerns seem to have arisen about the wisdom and propriety of such physical contact, which might spread disease or challenge social conventions around intimacy. Pax tablets were therefore introduced as a 'safe' means of exchanging a sign of peace long before the Covid-19 pandemic led to churches and cathedrals assessing the risks of shaking hands, and to the peace again being exchanged during worship without direct physical contact.

The Blackburn pax was hidden in a gravestone and discovered in 1820 during excavations for the building of the present cathedral nave.

RIGHT Rare pre-Reformation pax of the Madonna and Child.

BELOW A large, almost human-sized replica hangs in the south transept of Blackburn Cathedral, where it is a focus for prayer.

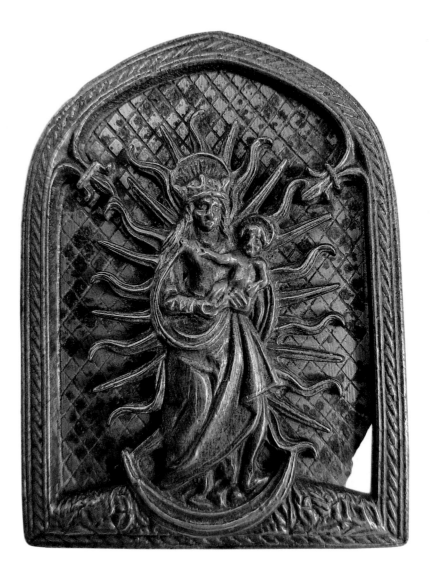

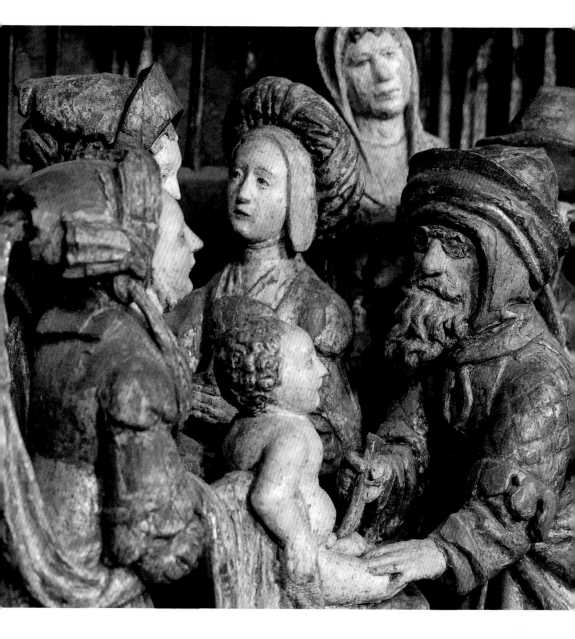

Gloriously detailed Flemish painted carving

CARLISLE CATHEDRAL

Brougham triptych (*c.*1515)

Carved oak, painted and gilded, 2.81 x 3.25 m (at central highest point)

www.carlislecathedral.org.uk @CarlisleCath

LEFT Detail of the panel depicting the Circumcision of Christ – note the 16th-century spectacles.

BELOW The vibrant Brougham triptych, a masterpiece of Flemish woodcarving, stands as the altar reredos in the Chapel of St Wilfred at Carlisle Cathedral.

THIS CARVED AND PAINTED OAK TRIPTYCH bears the symbol of the Antwerp Guild of Wood Carvers, confirming its place of origin. It is thought to have been in place in a church in Cologne until it was brought to this country by Henry Brougham (1778–1868) in the 1840s. Brougham was at one time Lord Chancellor of England and was also a prominent slavery abolitionist.

The triptych was installed in the family church of St Wilfred's, Brougham, where it was cut into three pieces to fit between the windows. The conditions in the church took their toll, and in the 1970s the triptych was reassembled, restored and displayed for seven years at the Victoria and Albert Museum. It was installed in Carlisle Cathedral in 1979.

The outer panels, which would have closed the altarpiece during certain liturgical seasons, have long since been lost, but the remaining sections of the triptych are outstanding examples of their type. As now configured, from left to right, the main panels depict the Road to Calvary, the Crucifixion and the Deposition and Lamentation.

Beneath the main panels, from left to right, are scenes from the life of Jesus: the Circumcision, the Presentation in the Temple, the Visit of the Magi and, to the far right, the figure of Jesse.

There are four miniature panels which show (on the left) the Scourging and the Crowning with Thorns and (on the right) the Easter appearance to Mary Magdalene and the risen Christ appearing to the Virgin Mary.

The detailing and vibrancy of the main panels are remarkable. The face and costume of every figure portrayed is individualised – carved and painted with great skill and with an empathy and imagination that gives the triptych an exceptional communicative power.

Quirky carved details that relieved a monk's life

CHESTER CATHEDRAL

Misericords (43 dating from 1380, 5 modern misericords)

Oak, approx. 32 x 62 cm

chestercathedral.com 🐦@ChesterCath

5 A.M. IN THE MIDDLE OF WINTER. You drag yourself out of bed, don your black serge frock and cowl and shuffle down the cold steps. Lauds – the first office of the day – might be part of your vocational life, but you cannot help but be tired. When singing you start to nod and lean back – but the arms of the misericord catch you. They offer support just when you need it.

Chester's misericords – literally 'mercy seats' – are situated in the cathedral's fourteenth-century quire. Their intricate carvings tell a range of stories and bring to life the reality of a monk's lived experience in medieval Chester. The misericord carvings only occasionally feature biblical or 'Christian' figures, with quarrelling couples, animals and mythical creatures such as griffins making up the majority. The medieval parts of the quire stalls are attributed to the workshop of William and Hugh Herland (*c.*1330–*c.*1411), carpenters to Richard II (r.1377–1399), with later replacements and alterations made by George Armitage and/or designed by George Gilbert Scott in the nineteenth century. The misericords and the quire stalls have been a constant in the building, and are widely regarded as the finest of their kind in Europe.

Their most impressive feature is their continued role in the everyday life of the cathedral church; visitors are often surprised that they can still sit and worship in the fourteenth-century stalls. They are a fantastic reminder of an unbroken tradition which has existed here for over nine hundred years.

RIGHT Medieval misericord with carving depicting a tiger hunt. Located on the *Cantoris* (north) side of the quire at Chester Cathedral.

BELOW The 14th-century quire at the heart of what was once a large monastic complex and continues to be used for worship.

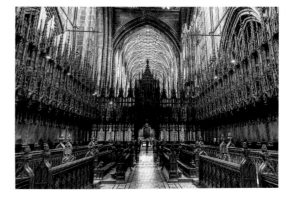

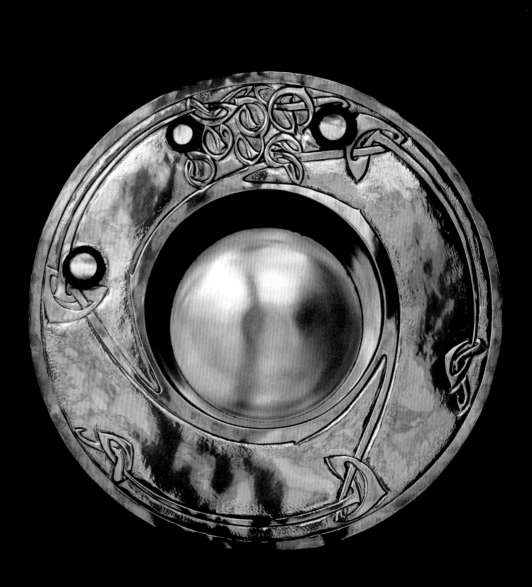

Gift of a renowned designer and friend of the cathedral

ST GERMAN'S CATHEDRAL, ISLE OF MAN

Silver alms dish (1932)

Archibald Knox (1864–1933)

Silver, L. 11 cm, diam. 25 cm

www.cathedral.im 🐦@CathedralIOM

Archibald Knox designed several pieces of silver for St German's ancient cathedral, which the League of St German, founded by Knox himself, was intent on restoring. Knox proclaimed himself 'Prior of the League … until an able person may be found who will undertake the work of the office'.

In seeking to restore the ruined cathedral, Knox anticipated the work of George MacLeod (1895–1991), who founded the Iona Community in 1938. The ancient abbey of Iona and the ancient cathedral of St German (still a picturesque ruin) were once in the same island empire, the Sodorensis, and both medieval buildings were erected by Abbot Simon of Iona, who became Bishop of Sodor and Man (1229–47).

One of the preeminent designers of the early twentieth century, Knox was the 'ghost designer' for Liberty of London and was especially well-known for his Cymric (silver) and Tudric (pewter) ranges. His name is behind the art nouveau style of Italy known as 'Stile Liberty'. The silver alms dish, lavabo bowl and jug held by the cathedral were the last pieces he made before his death in 1933. On his tombstone is the epitaph: 'humble servant of God in the ministry of the beautiful'.

The silver alms dish was made in memory of Knox's sister, Christina. It is inset with three mother of pearl roundels, representing the Trinity. It has 'S. German' engraved on the front, and also visible are the three legs of Man. The piece was made in Birmingham in 1932 by W. H. Haseler & Co.

LEFT Silver alms dish specially designed for the cathedral by Archibald Knox, designer for Liberty of London and supporter of the restoration of the old cathedral.

BELOW The new St German's Cathedral, Isle of Man, built in the 19th century and elevated to a cathedral in 1980, continuing an ancient foundation.

Inspirational view of women's contribution to society

LIVERPOOL CATHEDRAL

Noble Women windows (1908, replaced post-First World War)

Glass; windows 180 cm x 100 cm, screen 103 cm x 28 cm

www.liverpoolcathedral.org.uk 🐦 @LivCathedral

THE LADY CHAPEL OF LIVERPOOL CATHEDRAL has a unique set of windows dedicated to 'Noble Women'. The windows, at the West End in the atrium, were a gift from the candidates and associates of the Girls' Friendly Society, Liverpool Diocese.

The 'antique' glass is useful for portraiture as there is no distortion when painting. The windows have touches of silver oxide which, when fired, produces various shades, from pale yellow to deep orange. The windows were commissioned before women had the vote, and the subjects reflect a radical commitment to honouring women who had made significant contributions to society. Two rules were applied by the all-male members of the Stained Glass Committee in 1908. No living person should be depicted and women with Liverpool connections should be chosen where possible.

James Hogan of Whitefriars replaced the original windows – blown out by enemy action during the Second World War – using cartoons, photographs and salvaged fragments of the original glass. The painting, by Mr Burcombe of Whitefriars Studio, was intended to be as near as possible to the original. In 2022 the area was enhanced by a glass screen and by seating presented by the Trustees of the Josephine Butler Trust. Josephine Butler (1828–1906) is commemorated in the window.

The screen was designed by artist Sarah Galloway (b.1963) and reflects Butler's own qualities and achievements. It includes pieces of titanium oxide in quartz, linking the colour scheme with the windows. It is a powerful piece completing a space for private prayer and contemplation.

RIGHT Josephine Butler screen – commissioned from Sarah Galloway – leading to the Noble Women windows.

BELOW This detail of the windows features Queen Victoria and prime minister's wife Catherine Gladstone. Initiatives from organisations like the Girls' Friendly Society contributed to female suffrage ten years later.

Responding to destruction with beauty and art

MANCHESTER CATHEDRAL

Fire Window (1966)

Stained glass, 4.1 x 3.13 m
www.manchestercathedral.org 🐦 @ManCathedral

LEFT Manchester Cathedral's Fire Window by Margaret Traherne replaced an earlier window destroyed in an air raid in the Second World War.

BELOW This 15th-century parish church in the heart of Manchester became its cathedral in 1847. Recent renewal works, including a new floor with underfloor heating, have contributed to the regeneration of Manchester city centre.

IN 1485 THE STANLEY FAMILY, to whom the earldom of Derby was granted by Henry VII (r.1485–1509), endowed the St John the Baptist Chapel in what is now Manchester Cathedral. The chapel window depicted the Holy Child in the cradle and incidents in the life of the Child Jesus.

In 1936 the chapel was given over to the Manchester Regiment, and the Manchester and Lancashire Regiments' colours were hung there. On 23 December 1940 an incendiary bomb hit the north-east corner of the cathedral, causing severe damage and exposing the church to the elements. The fire prompted a 20-year restoration process overseen by the architect Sir Hubert Worthington (1886–1963).

As part of the restoration the 'seven lights window' was replaced by a 'five lights window'. The theme of the new window was the fires that burned after the bombing. Margaret Traherne (1919–2006) designed the window we see today, and also oversaw repairs to the damage caused to the Fire Window by an IRA bomb in 1996. The chapel is, in consequence, home to a marvel with which many of those born, educated, working or worshipping in Manchester will be familiar:

See for yourself in springtime,
when the wind and breeze may blow,
The moving tree branches make the
Fire Window flicker and glow.

Christ's suffering vividly portrayed

CADEIRLAN DEINIOL SANT, BANGOR
SAINT DEINIOL'S CATHEDRAL, BANGOR

Crist Mostyn (*c*.1450)
Mostyn Christ (*c*.1450)

Oak, H. 1.58 m

www.bangorcathedral.churchinwales.org.uk 🐦@Cadeirlan

IT IS, PERHAPS, HIS FACE that strikes us first. There is a boldness to the carving of his sloping eyebrows and his cast-down eyes; one can almost hear a deep, exhausted groan of resignation from his half-open mouth. There is a tenderness to his hair, which falls away in wavy locks, but a heaviness to the crown of plaited thorn branches above. He sits on a rock covered by his raiment, which the soldiers will soon part. At his feet, Adam's skull presages Golgotha. A winding rope binds him and will soon draw him to his fate. Christ, the Man of Sorrows, acquainted with grief and rejected by those he came to save, awaits his Crucifixion.

The life-sized Mostyn Christ arrived at the cathedral in the 1950s, on permanent loan from Lord Mostyn, whose forebears had placed the sculpture atop the minstrel screen at Gloddaeth Hall. Antiquarians have long debated his genesis. He was carved – probably in Wales (though some have seen northern French influences) and probably in the middle of the fifteenth century – from a single piece of oak, the back hollowed out with the long strokes of a gouge. He was made to be fixed to a pier, probably for the Dominicans at Rhuddlan, or perhaps for the monks at Maenan or the parishioners at Llanrwst. He is now one of the few surviving Welsh pre-Reformation wooden sculptures of his class. During his years of wandering he lost his right arm and most of his left – but the loss if anything adds to his devotional power. Time and prayer contribute to this Christ's Passion.

RIGHT The Mostyn Christ, a rare, devotional, bound rood, is a life-sized, realistic, seated figure of Christ with the emblems of the Crucifixion.

BELOW Wooden ceilings of the nave, crossing tower and choir – part of Sir Gilbert Scott's restoration program between 1868 and 1884. Established as a clas by Deiniol in 525, the cathedral is currently the seat of the Archbishop of Wales.

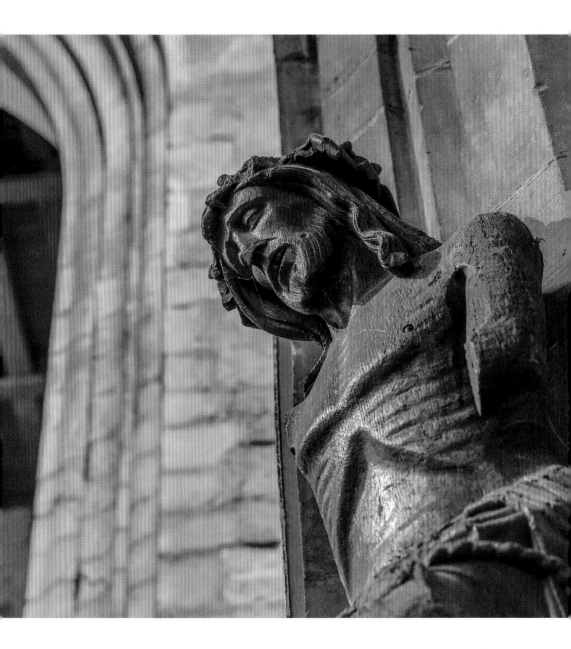

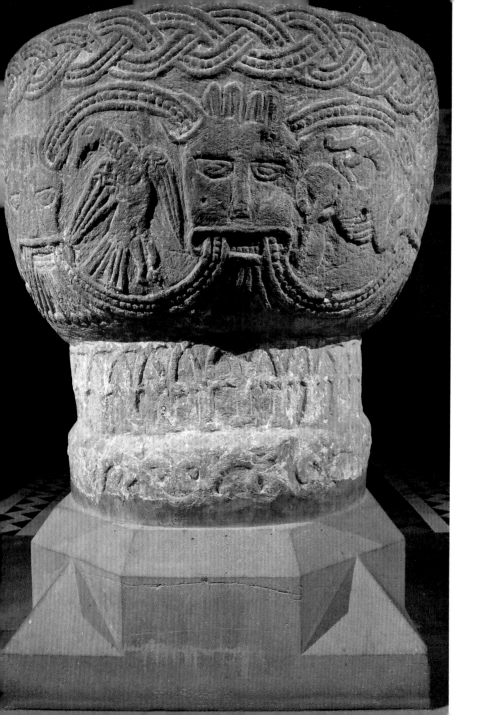

Robust Celtic images once buried, now celebrated

EGLWYS GADEIRIOL ABERHONDDU
BRECON CATHEDRAL

Bedyddfaen Normanaidd (*c.*1190)
Norman font (*c.*1190)

Stone, H. 83 cm, diam. 84 cm

www.breconcathedral.org.uk 🐦 @BreconCathedral

THE SITE OF BRECON CATHEDRAL has been a centre of Christian worship for over nine hundred years, although little now remains of the original building. It was established in 1093 as a Benedictine priory and became a parish church at the time of the dissolution of the monasteries. Situated in the beautiful landscape of the Brecon Beacons National Park, in 1923 it became the cathedral church of the newly created Diocese of Swansea and Brecon and the seat of the Bishop of Swansea and Brecon.

The cathedral is home to the largest Norman font in Wales. Dating from *c.*1190, it is thought to be late Norman or 'transitional' because it has Gothic pointed arcading around its stem. It is of a lighter stone than the sandstone of the walls, and it must at some point have been hidden underground because the carvings on the west side have worn away. The grotesque symbolical carvings – a tree of life, a scorpion, an eagle, a fish and three green men – survive, looking more Celtic than Norman. The carvings on the bowl are in the early Norman style and belong to the Hereford school, resembling the style of Kilpeck and Leominster. The column on which the bowl stands, meanwhile, has interlaced arches characteristic of the later Norman period.

The font is still used today. Water for the urn was presented to the cathedral in March 1970 by Brecknock Society and Museum Friends in memory of Brecon native Dr Frances Hoggan (1843–1927). She was a pioneering medical practitioner, researcher and social reformer who played a significant role in the battle for women in the UK to study medicine in the nineteenth century.

LEFT Early medieval font illustrating Celtic and Norman design and motifs.

BELOW Brecon Cathedral, mother church of Swansea and Brecon diocese and set in the Brecon Beacons National Park.

Powerful imagery in jewel-like Pre-Raphaelite colours

EGLWYS GADEIRIOL LLANDAF
LLANDAFF CATHEDRAL

Triptych Rossetti (1856–1864)
Rossetti triptych (1856–1864)
DANTE GABRIEL ROSSETTI (1828–1882)

Oil on canvas, central panel 300 x 183 cm; side panels H. 300 cm x W. 90 cm x D. 14 cm

www.llandaffcathedral.org.uk 🐦@LlandaffCath

DANTE GABRIEL ROSSETTI's *The Seed of David* triptych was originally positioned behind the cathedral's high altar, but Rossetti was never satisfied with this setting. In the Second World War the triptych was packed in crates and stored safely. During the cathedral's post-war restoration, architect George Pace used the triptych as a reredos in the new Illtyd Chapel. In 1989 Donald Buttress (b.1932) provided a frame of muted richness of distressed gold leaf and had the wall behind the triptych sumptuously decorated in dark colours by Peter Larkworthy. This setting might finally have satisfied Rossetti.

The painting was one of Rossetti's first major commissions and he was wildly enthusiastic – 'a big thing which I shall go into with a howl of delight'. He quickly chose as his subject the Nativity of Christ, but he was anxious to avoid producing a conventional depiction: a 'condensed symbol' rather than a 'literal rendering' (in Rossetti's words), the triptych conflates the separate visits of the shepherds and the kings.

The title emphasises Christ's descent from David, who is depicted on both wings of the triptych: on the left as a shepherd boy and on the right as a king. The centre panel shows that Christ can be worshipped by both rich and poor, shepherd and king, while a shepherd's crook and a crown are laid at his feet. The infant Christ holds out his hand to be kissed by a poor shepherd and his foot by a king, showing the superiority of poverty over wealth.

RIGHT Rossetti's *The Seed of David* triptych in the Illtyd Chapel – a sumptuous pre-Raphaelite statement on social equality.

BELOW The nave of Llandaff Cathedral, Cardiff, with Jacob Epstein's striking *Majestas, Christ in Majesty* – part of architect George Pace's post-Second World War scheme.

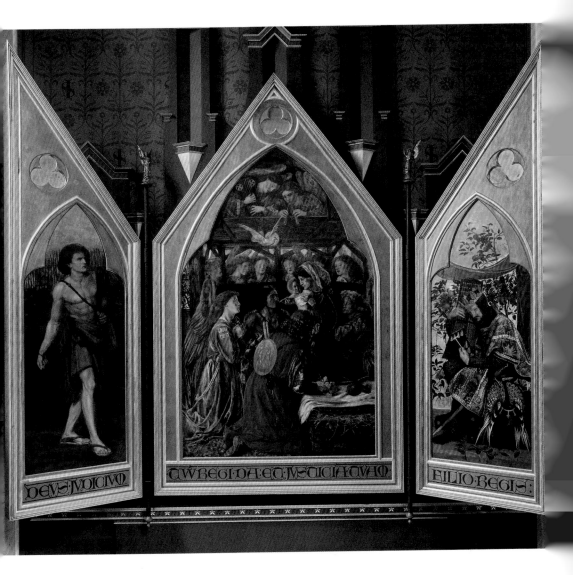

Ever-changing but eternal: sculpture at the heart of the cathedral

CADEIRLAN CASNEWYDD
NEWPORT CATHEDRAL

Crog Casnewydd (2020)
Newport Rood (2020)
TAY SWEE SIONG (b.1986)

Black powder-coated steel, L. approx. 2.5 m
www.newportcathedral.org.uk 🐦@newportcath

NEWPORT CATHEDRAL HAS BEEN a sacred space for over one and a half thousand years, making it one of the oldest Christian sites in Wales. St Woolos (Gwynllyw) founded a place of prayer on this site in the fifth century, following a vision and calling by God. It is likely that he was buried under the floor in what is now the St Mary Chapel, the oldest part of the cathedral. St Woolos Church became the cathedral for the newly formed Church in Wales Diocese of Monmouth in 1949, having become a pro-cathedral shortly after the diocese's creation in 1921.

The *Newport Rood* is the newest of the cathedral's treasures. It was installed at the end of the first Covid-19 lockdown in 2020 and hangs at the entrance to the chancel arch. This striking modern work of art by the Singaporean artist Tay Swee Siong is made from wire; it hangs near where the medieval rood would have been, adjacent to the high-level rood-loft doorway.

The work's appearance appearance depends on where the viewer stands. From some positions it almost blends into the background and becomes invisible. When the sunlight shines through from the south, it can appear radiant. With the roofs as its backdrop, it is prominent and full, hanging in the heart of the cathedral. With the light passing through it from the east window of Patrick Reyntiens (1925–2021), designed in the 1960s by John Piper (1903–1992), it exudes glory.

These four perspectives provide a powerful reflection on the place of the cross: invisible to some, but radiant, prominent and shone through with the glory of God.

LEFT The *Newport Rood* – one of the newest work of religious art in an ancient church.

BELOW Newport Cathedral, seat of the Bishop of Monmouth. Founded as a place of prayer by St Woolos around 500, it is one of the UK's earliest surviving Christian foundations.

Welsh language and faith commemorated

CADEIRLAN LLANELWY
ST ASAPH CATHEDRAL

Cofeb y Cyfieithwyr (1892)
First Welsh-language Bible and Translators' Memorial (1892)

Hollington and Ancaster stone with green marble tablets, H. 9 m, diam. 2 m

www.stasaphcathedral.wales 🐦@StAsaphDiocese

THE TRANSLATORS' MEMORIAL, unveiled in 1892, marks the 300th anniversary of the 1588 Welsh Bible translation. It celebrates eight men, most of them from Denbighshire and Conwy, whose pioneering work may well have helped save the Welsh language.

RIGHT William Morgan's first Welsh Bible of 1588, authorised by Elizabeth I, in St Asaph Cathedral.

BELOW The Bible Translators' Memorial in front of St Asaph Cathedral. A Gothic tower on a stepped plinth, loosely based on Eleanor crosses, it features statues of eight men whose work helped preserve the Welsh language..

There was a growing argument in Tudor Britain for translating the Bible into the language of the people rather than having it read out in Latin. A translated English Bible could not be read by the majority of the Welsh-speaking population, however. Supported by Elizabeth I (r.1558–1603), who wanted to unite her kingdom, a law was passed in 1563 to permit a Welsh translation and to place a copy in every church in Wales.

Richard Davies (d.1581), former Bishop of St Asaph, played an influential role in the passage of this legislation, but the translation of the Bible required specialist language skills in addition to knowledge of the religious texts. Davies collaborated with Thomas Huet and William Salusbury – working on an English-Welsh dictionary – on the translation of the New Testament in 1567. The text was translated from the original manuscripts of Greek and Hebrew to make it more accurate.

William Morgan (1545–1604), with the help of Edmund Prys and Gabriel Goodman, translated the whole Bible into Welsh over ten years. Morgan's experience with poetry, along with his knowledge of languages, meant that this version aided its readability.

A revision was printed in 1620 by John Davies and Richard Parry, and Edmund Prys published a new translation of the Psalms in 1621. The original Bibles are now on display in St Asaph Cathedral.

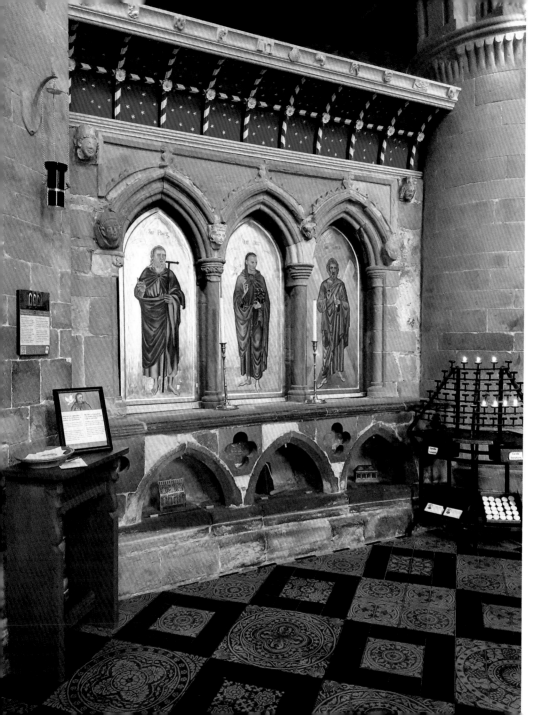

Medieval shrine and modern pilgrimage

EGLWYS GADEIRIOL TYDDEWI, SIR BENFRO
ST DAVIDS CATHEDRAL, PEMBROKESHIRE

Creirfa Dewi Sant (1275)
Shrine of St David (1275)

Restored medieval shrine of St David, Caerbwdi stone, H. 3.17 m, W. 1.82 m, D. 1.38 m

www.stdavidscathedral.org.uk 🐦 @StDavidsCath

LEFT The medieval shrine of St David is a rare survival from the age of pilgrimage. Some remnants of the original extensive paintwork are still visible. The shrine was partly restored in 2012 with icon style paintings.

BELOW Much of the current St Davids Cathedral was built in the period after 1181 on the site where St David had established his monastery in the 6th century.

SIXTH-CENTURY WELSH MONK DEWI SANT, or St David, was born, lived and died peacefully in Mynnw or Menevia, west Wales, where he was buried 'in his own church'. His reputation and a strong spirit of place led to countless pilgrims journeying across water or land to visit. In 1123 Pope Calixtus II declared two pilgrimages to St Davids to be worth one to Rome. In 1181 work began on the current cathedral. In 1275 the tomb shrine was constructed as a focal point for the increasing numbers of pilgrims, housing recently discovered bones claimed as those of Dewi lost during Viking raids.

Despoiled at the Reformation, with relics removed and pilgrimage forbidden, the shrine still remained at the heart of the cathedral and was partially restored in 2012. Five striking icons depict St David, St Patrick, apostle St Andrew, St David's mother St Non and St Justinian, David's confessor. Dewi Sant is depicted barefoot with characteristic Celtic tonsure, white dove of the Holy Spirit and Gospel in hand.

The shrine has seven quatrefoil offertory niches and six larger arched prayer niches. The medieval prayer niches have an amazing, even mystical acoustic which medieval pilgrims felt as they knelt in prayer, bending their heads close to the saint. Kneelers placed in front of the niches encourage modern visitors to share this experience.

A service of Pilgrim Prayers is held at the shrine every Friday at noon and is now livestreamed with a regular global audience.

GLOSSARY

alms dish: Collection plate

apse/apsidal: Semi-circular end of a church

basilica/basilican: Oblong building ending in an apse; used in ancient Roman courts and public buildings and in early Christian churches

boss: projection often carved e.g. at the intersection of ribs

cartulary: Book holding charters

catacomb: Underground cemetery with recesses for tombs from Roman times

cathedra: Seat or throne of a bishop

cathedral: Church containing the cathedra, serving as the mother church of a diocese

chancel: East End of church traditionally containing the altar

clas: Early monastic missionary foundation found in Wales

clerestory: Upper storey of nave walls of a church pierced by windows

diocese: Administrative area consisting of parishes and a cathedral over which a diocesan bishop exercises oversight

Dissolution (of the monasteries): Process of closing monasteries, priories, convents and abbeys and appropriating their resources, carried out by Henry VIII between 1536 and 1541 following his break with Rome

Eleanor Cross: 12 stone monuments built between 1291 and 1295 by Edward I in memory of his wife Eleanor of Castile. The crosses mark resting places for her body between the East Midlands where she died and Westminster Abbey

font: Bowl filled with water for Baptism

iconoclast: Destroyer of images used in religious worship – in England and Wales, particularly after the Reformation

Lady Chapel: Chapel dedicated to the Virgin Mary, particularly popular in the later Middle Ages

lavabo bowl: Bowl for ritual washing of the celebrant's hands in the Eucharist

lavatorium: communal washing place

misericord: 'Mercy seat' designed for clergy to lean against when standing during long services. The underside is often carved, sometimes with wildly imaginative scenes

Oxford Movement: A movement of High Church members in Oxford from the 1830s putting emphasis on Sacramental and other early church traditions. This resulted in greater emphasis on the importance and decoration of the altar and chancel

pax: A pre-Reformation object kissed as a substitute for the Kiss of Peace in the Mass

Reformation: In England and Wales, the process by which the Church broke away from the authority of the Pope and the Roman Catholic Church in the 1530s. Theologically the changes were linked to the wider European Protestant Reformation, but they were driven by the political forces around Henry VIII's desire for an annulment of his marriage to Katherine of Aragon

reliquary: A container or shrine in which sacred relics are kept

reredos: Decoration above or behind an altar

rood: A cross or crucifix, the term is most often used when set on a beam over the entrance to a chancel

Sacrament: Means by which Christians receive divine grace, through participation in certain rites such as Baptism and Holy Communion

scriptorium: A 'place for writing' where texts and books were copied and illuminated

sedilia: Seats, near the altar and usually in the chancel, used by the officiating priest and assistants during Mass/Eucharist

stoup: A basin of holy water at the entrance of a church

styles of architecture:
Romanesque/Norman: round arched, thick stone walls and columns in imitation of Roman c.1066-1190 (Durham Cathedral)

Transitional: buildings using round arches and early pointed arches (Chichester Cathedral) c.1150-1200

Gothic: pointed arches, soaring height, thin-walled architecture; in UK divided into three phases; *Early English* (Salisbury Cathedral), *Decorated* (Exeter Cathedral) and *Perpendicular* (East End and cloister at Gloucester Cathedral), c.1175-1540

Classical: seventeenth century onwards – derived from ancient Roman and Greek architecture, often interpreted by Renaissance practitioners (Wren's St Paul's Cathedral)

Gothic Revival: alongside classical architecture, the late eighteenth and more systematically the nineteenth century saw a revival of Gothic forms in the UK (Truro Cathedral)

Tournai marble: A blue/black limestone from Belgium used in the twelfth and early thirteenth centuries for fonts and stoups

triforium: Space in a church under the aisle roof, opening onto the nave through an arcade

triptych: A picture or relief carving on three panels used as an altarpiece

INDEX

We are very grateful for permission to use photographs. It should be assumed that all are subject to copyright. Peter Smith, front cover, p103; © Dean and Chapter of Winchester Cathedral, front flap, 8, 43; Lincoln Cathedral 2–3, 56; Bradford Cathedral/Philip Lickley 4; Luke Hughes 7; © Whitefoot Photography/Southwell Cathedral Chapter 9; Chapter of Canterbury Cathedral 11–12; Marcus Green 12, 25, 28–29, 32–33, 37, 42, 45, 50, 65, 73, 89–90; Guildford Cathedral 13; Steve Hartridge Photography 14; Jacob Scott 15; Southwark Cathedral Chapter 16–17; Julia Low 18–19; © Graham Lacdao/ The Chapter of St Paul's Cathedral 20–21; © Dean and Chapter Westminster Abbey 22–23; Bristol Cathedral/ Lee Pullen 24; Exeter Cathedral/Peter Smith 26; Exeter Cathedral/Emma Laws 27; © Mark Charter 30–31; Daniel Smith 34; Ash Mills 35, 40; Dean and Canons of Christ Church 36; Portsmouth Cathedral 38–39; Kevin Caldwell © Off the Rails Australasia Pty Ltd 41, back flap; © Alastair Carew-Cox 44; Coventry Cathedral 46; Gerda Muldaryte 47; Derby Cathedral 48–49; Hereford Cathedral/Folio Society 51; Richard Jarvis and Aidan McRae Thomson of Norgrove Studios Ltd 52–53, inner back flap; Paul Barker © Archbishops' Council 54, 60; Lichfield Cathedral Photographers 55; Janet Gough 57, 106; © Bill Allsopp/Southwell Cathedral Chapter 58; © Southwell Cathedral Chapter 58–59, back cover; James Prior/Worcester Cathedral 61; Mark Cazalet 62–63; Julia Scott 64; Bill Smith/Norwich Cathedral 66–67; Matthew Roberts 68–69; Pete Huggins 70–71; Bradford Cathedral/Katie Glover 72; Chapter of Durham Cathedral 74–75; Geoff Miller 76; Michael Baister Photography 77; Gary Lawson © Ripon Cathedral 78; Joseph Priestley © Ripon Cathedral 79; Patrick Fitzsimons 80–8; Mark Flynn © The Chapter of Wakefield Cathedral 82–83; © Chapter of York 84–85; Blackburn Cathedral 86–87; Danny Fowler 88; Sarah Kirkup 91; Patricia Tutt 92; Simon Park 93; Clarebatesphotography 94–95; Angelo Hornak/ Manchester Cathedral 96–97; Dave Custance for St Deiniol's Cathedral 98–99; Mike Williams 100; Eryl Jones 101; Christopher Preece 102; Ian Black 104–105; St Asaph Cathedral 106–107; Christopher Limbert © Dean and Chapter of St Davids Cathedral 108; Ross Cook © ArchaeoDomus 109.

Janet Gough would like to thank all the deans and cathedrals for responding so admirably to the cathedral treasures initiative. In particular, she would like to thank the steering group who worked tirelessly to realise the book and while this list is far from comprehensive, from the cathedrals: Jane McArdle, Rowena Pailing, Maggie Myers, Frances Bircher, Emily Lanigan, Judith Curthoys, Alison Cullingford, Barbara McGowan, Emma Laws, Rebecca Phillips, Roger Heath-Bullock, Paul Velluet, Chris Milton, Val Garrett, Gregory Platten, Michael Diamond, Fern Dawson, Nicholas Rank, Katie Grainger, Stuart Haynes, Val Jackson, Jan van der Lely, Mike Breaks, Marion McClintock, Peter Doll, Tim Alban Jones, Julia Barker, Jacob Scott, Geoffrey Harbord, Jon Dollin, Kevin Walton, Lorna Kernahan, Jackie Feak, Karen Maurice, Mari James, Mark Charter, John Bailey, Ryan Collier-Grint, Rob James, Bob Frost, Tony Trowles, Roland Riem, Eleanor Swire, David Morrison, Helen Rawson and Jonathan Neil-Smith.

First published in 2022 by
Scala Arts & Heritage Publishers Ltd
305 Access House
141–157 Acre Lane
London, SW2 5UA
www.scalapublishers.com

Director's Choice® is a registered trademark of Scala Arts & Heritage Publishers Ltd.

Project managed by Bethany Holmes
Designed by Linda Lundin
Printed and bound in Turkey
978-1-78551-453-1
10 9 8 7 6 5 4 3 2 1